Maxwell Bates:

Canada's Premier Expressionist of the 20th Century

Maxwell Bates:

Canada's Premier Expressionist of the 20th Century

His Art, Life and Prisoner of War Notebook

by Nancy Townshend

Maxwell Bates: Canada's Premier Expressionist
of the 20th Century
His Art, Life and Prisoner of War Notebook
by Nancy Townshend

Author: Nancy Townshend, Calgary
Editor: Meaghan Craven, Calgary
Book design, duotones and colour management :
Nelson Vigneault, CleanPix Corp., Calgary
Printing: Marquis Book Printer, Montreal

Co-publishers and co-distributors:
Snyder Hedlin Fine Arts Ltd.,
www.snyderfinearts.com
gordon.snyder@snyderfinearts.com

Nancy Townshend,
ntownshend@telus.net

Library and Archives Canada Cataloguing in Publication
Townshend, Nancy, 1948-
Maxwell Bates : Canada's premier expressionist of the
20th century : his art, life and prisoner of war notebook /
by Nancy Townshend.

ISBN 0-9737268-0-6

1. Bates, Maxwell, 1906-1980. 2. Painters-Canada-
Biography. 3. World War, 1939-1945-Personal narratives,
Canadian. I. Snyder Hedlin Fine Arts II. Title.

ND249.B32T69 2005 759.11
C2005-900090-2

Printed in Canada

On front cover: Maxwell Bates, *Cocktail Party* (1977)
oil on canvas, 101.6 x 121.9 cm., Private Collection

On back cover: Maxwell Bates, *Café* (1932)
pencil and watercolour, 40.5 x 33.3 cm., Private Collection

Collaborators:

Nancy Townshend discovered Bates's Prisoner of War Note-book, a national and international treasure, deep in the Maxwell Bates *fonds*, Special Collections, University of Calgary Library. This essay bears the fruits of that finding, as well as accumulative knowledge about Bates gained from two recent projects. Nancy was content specialist for the Virtual Museum of Canada site on Maxwell Bates: Artist, Architect, Writer <www.maxwellbates.net> hosted by the Art Gallery of Greater Victoria. As well she is co-curator of *Maxwell Bates: At The Crossroads of Expressionism* for the Edmonton Art Gallery with Michael Morris in 2004 which will tour to Calgary, Saskatoon and Victoria in 2005 and 2006. Ms. Townshend received her MA in the History of Art from the University of Toronto in 1973.

Snyder Hedlin Fine Arts Ltd. is located in Edmonton. It provides professional art consulting services to corporations and private collectors and acts as an agent for Canadian artists. It curates exhibitions and publishes art publications. Snyder Hedlin Fine Arts Ltd. is owned and operated by Gordon Snyder and Ralph Hedlin.

Nelson Vigneault has worked in graphic design for the last 35 years, specializing in high-end art reproduction. Clients of his company, ThinkDesign Limited, include the National Gallery of Canada, Ottawa and the Museum of Modern Art, New York. Nelson is the President and CEO of CleanPix Corporation, a digital image management company.

Detail of Bates's Horoscope
Maxwell Bates *fonds*, 439/89.1, Box/file 11.9
Special Collections, University of Calgary Library

in honour of the great Canadian artist
Maxwell Bates
(1906–1980)

To view most of the artworks by Maxwell Bates
discussed in this essay, and launch zoom viewer,
please visit the Virtual Museum of Canada site

Maxwell Bates: Artist, Architect, Writer
www.maxwellbates.net

hosted by
the Art Gallery of Greater Victoria

MVC
MUSÉE VIRTUEL ❦ CANADA

Table of Contents

Introduction

Maxwell Bates contributed uniquely and profoundly to Expressionism, one of the major international art movements of the twentieth century. Bates painted "Art for Humanity." He experienced war from the inside as a prisoner of war artist and writer. To date these categories have been overlooked in twentieth-century Canadian art history. This paradox—that Bates was great by any standard yet until 2004 overlooked—and others characterize Bates right from the start. While Alberta, his home province for thirty-one years, celebrates its first centenary in 2005, it is fitting that a re-evaluation of Bates's art and life occurs now.

Expressionism set free the personal and subjective ideas and emotions of the artist. Germany's Ernst Kirchner, Erich Heckel, Emil Nolde, Kathe Kollwitz, George Grosz and Max Beckmann and Austria's Egon Schiele—all necessarily Expressionists—expressed their personal insights about life around them in their art. So, too, Canada's Maxwell Bates. Expressionism fundamentally provided an outlet for Bates's deep social conscience and tremendous affirmation of humanity. Bates's Expressionism came from his search for meaning for what is real, and his value of human life.

At the crossroads of Expressionism—just after liberation as a prisoner of war in Germany in 1945—Maxwell Bates followed a profound path. Because of his compassion and empathy, Bates humanized and championed marginalized figures, initially Jewish concentration camp survivors while still in Europe in his art, then prairie people upon his return to Canada.

This essay offers new research and insights into the evolution of Canada's Expressionist artist, Maxwell Bates: from the positive role of Calgary (1906–1931), to the critical art events affecting Bates in London (1931–1939), to the importance of Bates's POW Notebook and its relationship to his art and life, and to the continuing fruition of Expressionism on his return to a Canadian context, first in Calgary (1946–1962), then in Victoria (1962–1980).

Until his death in 1980 Bates worked out his remarkable unitary ideas recorded in his POW Notebook, especially his thoughts on dilating "the present" to "eternity." To achieve this Bates worked intuitively, from specifics or "particulars," especially from people of his times, to personally meaningful universal truths such as: the solitude of the human condition, destiny/free will, workers, environment and its effect on people, life/death, appearance/reality, and Romanticism. Ultimately Bates places these truths—many polarities along the human continuum—at the service of the chief meaning for his art and his original and most profound contribution to Expressionism: bondage and freedom within the human condition.

Thus through the expressive power of his art, Bates's themes—of prairie people, labourers, drinkers, cocktail parties, fortune tellers, chess players, families, Punch and Judy, puppets, scarecrows, crucifixions, angels—play out his grander world view.

Bates shows people totally vulnerable, at the mercy of various societal power struggles. ("We are all puppets, Mr. Eaton,"[1] Bates once observed.) His ability to humanize and draw attention to the marginalized figures of society in his art recalls Velasquez with his dwarfs[2] ("dwarfs were kept to be manipulated"[3]), Manet with his beggar-philosophers,[4] and Picasso's depiction of circus characters. ("Court jesters walk the line between life and death."[5]) But, at the same time, Bates gives his people great strength of character. Can there not be a better world, a better life, Bates implicitly asks in his art? Can we not be vigilant of our freedom within human relationships?

Life-long friend P. K. Page also believes Bates's art has a higher purpose: "Anyone who has had a vision of what man could become must thereafter see him in his partial evolution as deformed. 'Man, poor man, half animal, half angel.' Vile only in relation to his possibilities. I believe this to be the essence of Bates' message."[6]

Bates's art has a directness, simplicity, and intensity of expression which served the Expressionist canon well, as did his intense colour, bold patterns, distorted forms, highly expressive contours, use of contrast and the integrated figure/ground. To make his art more intriguing and to obfuscate his serious intent, Bates—at his prime—used conceits[7] of wit, paradox, and irony, sometimes in plausible allegories of extraordinary inventiveness, in his essentially twentieth-century Mannerist way of working. These conceits deliberately confound and lighten the impact of Bates's meaningful universal truths, which are often ultimately about bondage and freedom. But, nevertheless, these truths are often present. "Bates was a very literary man who understood the value of putting a fly in the ointment."[8] This way of working was consistent with Bates's way of thinking as the following quote by Bates about his five-year POW experience shows:

> Many of us had come to despise things we had valued before, and had learned to value things that we had despised or overlooked. It was up to us whether we lapsed back into the old grooves of hypocrisy, snobbishness and humbug. At least some of us had been freed.[9]

Part I

The Making of a Great Canadian Expressionist

Calgary (1906–1931)

Calgary helped make Maxwell Bates. He thrived on the positive formative experience that Calgary provided for the young proto-Expressionist.[10] Calgary-born Bates pursued an artist's subjectivity, art of social commentary, art for art's sake, and an anti-naturalistic aesthetic rather than the prevailing naturalism proselytized by newly arrived artists/teachers Lars Haukaness and A. C. Leighton. And Bates, as the city's foremost pioneer modern artist, helped define Calgary.

In isolated Calgary, Bates formulated his ideas on art, which by 1929 brought him paradoxically to Expressionism, an international movement in his painting *Family With Pears* (1929). Bates believed:

> I don't think I've changed my vision essentially since 1930, before I went to England and the greatest influences I had, I suppose, up to that time, were Daumier and Degas,...Gauguin, Van Gogh and Cezanne.[11]

Self-taught and highly creative, the young Bates was attracted to, and studied Daumier's lithographs, art serving social justice, in his family's 1904 *Studio* volume.[12] Through them, Bates learned about the expressive possibilities of art. "Daumier was perhaps the greatest single influence."[13] From Daumier, Bates learned to elevate the specific to the universal, the art of exposing human drama, draughtsmanship, composition, and value contrasts (note the ink drawing *Fireworks* (c. 1921). Bates copied many of the fifty-six black & white and eight colour illustrations by Daumier in the *Studio* volume, such as "Un Avocat qui Plaide," "Cause Criminelle" and "Don Quixote et Sancho Panza" (for *Le Charivari*).[14] With his early insights into the human condition, Bates masterfully presents, using loose line and wash, human confrontation, a unique interest in Canadian art at this time, in the ink drawing *In The Kitchen* (1921). Later he exploited the pictorial roles a subsidiary figure could provide, such as the monkey-face waiter.

An upbringing in a highly cultured Anglo-Canadian family in Calgary fundamentally shaped the young artist. Bates grew up in a well-designed two-storey, Craftsman Prairie house, which his father, architect William Stanley Bates, designed in 1907 (and enlarged in 1912). Situated kitty-corner to Senator James Lougheed's home, and next door to the present-day Ranchman's Club, the Bates's home stimulated the young artist: "earliest memories of patterns and colours of curtains to bed room."[15]

A frequent visitor in the 1920s, P. K. Page recalled:

> It is the living room of the house that I remember especially...A deep-piled carpet of a miraculous peacock blue, bordered with the Greek Key design in black on cream, ran the length of the room...The furniture—dark oak—was intricately carved, in many cases by the Bateses themselves, and innumerable *objets d'art*—fashioned of silver or ivory—covered the occasional tables....

> There, under the hanging Tiffany lamp, we supported unwieldily copies of *Chums*...Or we drew, in our little island of light, above the deep reds and blues of the Turkish carpet. Inset on either side of the fireplace were bookcases with leaded glass *art nouveau* doors, containing the latest copies of *The Studio*...[16]

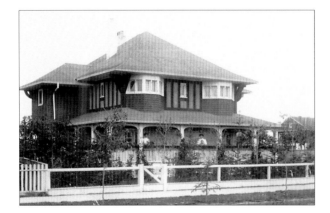

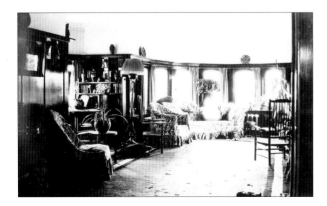

From the age of five Bates examined every image in the twenty-three *Studio* volumes 1904–1915 and made copies in pencil, pen and ink, and watercolour of some of them.

As a child Bates developed certain characteristics that made him receptive to Expressionism. He was aware he lived in a hostile world; his first original drawings were of self-contained castles, "fortified retreats from an incomprehensible world, chaotic and violent."[17] He began to develop his ideas on bondage and freedom, as is evident in his poem "Kite" (1928):

> See the kite!
> See it dive and struggle, terribly alive.
> How its tormentors scream
> With delight.
> Look! it feels the air, the cool play
> Of the wind. Now the boys are left behind,
> Insignificant. It is serene
> In its flight.
> The string is blessed; bondage has no sting
> At that height.

and in the ink drawing and watercolour *Kite Flyers* (1921). He understood the polarities of free will and destiny. Already displaying the characteristics of a Romantic artist, Bates was interested in the unusual, the strange, and sometimes, in the bizarre.

Front of Bates house c. 1910 designed by W.S. Bates
732 13 Avenue S.W., Calgary
Maxwell Bates *fonds*, 439/89.1, Box/file 9.8
Special Collections, University of Calgary Library

Living room interior, Bates house
photo courtesy W.A. (Bill) Bates

Paramount in the young artist's development was Bates's relationship with his father, who built Calgary's Grain Exchange (1909) and Burns (1912) buildings. With each new Modernist exploration, "my father, an architect, was often horrified. Strangely enough that seemed to me reason to feel encouraged."[18]

Bates and his Dad, the architect William Stanley Bates
photo courtesy W.A. (Bill) Bates and Janice Starko

To Calgary's Carnegie Library four blocks away Bates owed "an incalculable debt."[19] He read all sixty books on art (including those on Japanese and Chinese art), literary criticism, philosophy, psychology, and poetry. Novels by Dostoevsky, Tolstoy, and Turgenev particularly interested him. With their probing into the human condition and moral and philosophical questions, they seemed "very apropos of my life somehow."[20] And the art he created at this time reflected this literature.

Red Flag (1921) captures political unrest in a far-away European town with amazing draughtsmanship for a fifteen-year-old, as does *Revolution* (c. 1922). The linocut *Siesta* (1927), with its elongation of the figure and expressive use of contour and line, indicates an early sympathy for the workman, a strong theme in Bates's art.

Bates's intense interest in Modernism, shared with fellow artist William Leroy Stevenson in 1925, led Bates to affirm:

> That period in Calgary when I used to meet Stevenson (1925–1931) was a very important time in my life because I was developing my ideas on art and literature.[21]
>
> And they haven't changed so it must have been important.[22]
>
> We were of enormous help to each other.[23]

Initially they absorbed *The Art and Craft of Drawing* by Vernon Blake, which Bates special ordered. They examined with the greatest care every reproduction in the latest issues of *Apollo*, *Connoisseur*, and *Studio* including some "great expressionist work."[24] Besides Daumier, Bates admired Goya with his outrage at injustice expressed in such work as *3rd of May, 1808*, his use of subjective realms, imagination, and ridicule in *Les Caprichos* and *Disasters of War* (1810–1823) (which influenced Daumier).[25] He studied and copied

the oil paintings by Velasquez[26] and admired the works by Degas, Toulouse-Lautrec, Van Gogh, Gauguin ("we admired Gauguin and spent hours analysing reproductions of his paintings"[27]), and Cezanne. They read Roger Fry's *Vision and Design* (1920) and Clive Bell's *Since Cezanne* (1922) and *Civilization* (1928), with his concept of "plastic design" and ideas on rhythm.

For five years Bates and Stevenson discussed each other's work two to three times per week. They repudiated the Beaux Arts training Lars Haukaness gave them, during an eighty-hour course he taught two evenings a week from 1926–27 and 1927–28, finding it confining and irrelevant. Instead they explored Modernism. At the same time, Bates developed his visual memory.

In addition, even at this early stage, "Rhythm was of immense importance to us."[28] *Auction* (1929) is one of those watercolour compositions that uses rhythmic repetition of shapes.

By 1927 Bates created Synthetist[29] and proto-Fauvist figurative works such as the abstract *Washerwoman* (c. 1927, see p.17), even non-objective[30] art including *Male and Female Forms* (1928) for which Bates and Stevenson were expelled from the Calgary Art Club and barred from ever exhibiting in public buildings again. "It was good to have reached these people, but we did not appreciate this at the time."[31] Although exhibiting in New York,[32] Toronto, Vancouver, and Ottawa, locally they received "severe criticism of the extreme modernism of their paintings."[33] Neither the Calgary Public Museum nor private collectors purchased their works. In fact Bates and Stevenson were excluded from membership in the inaugural Alberta Society of Artists (ASA) in 1931. This society led by A. C. Leighton favoured eighteenth- and nineteenth-century British tonalism. Bates described the ASA as: "a very homogenous club under the influence of the British school."[34]

Instead Bates and Stevenson examined first-hand the important late nineteenth-to early twentieth-century European works at the Art Institute of Chicago (AIC) for three weeks in 1929, and confirmed their life direction. Described as "a revelation not only to Chicago but to the world,"[35] AIC's Helen Birch-Bartlett Memorial Collection featured works by Van Gogh, Gauguin, Seurat, Cezanne and Matisse, and Lautrec's *At The Moulin Rouge* (1892–95), and Picasso's *Old Guitarist* (1903). Bates singled out Cézanne's "construction" and Van Gogh's "colour and vigour with which he worked."[36]

On his return to Calgary, Bates's art showed similar concerns to the Institute's *La Berceuse (Madame Roulin)* (1889) by Van Gogh: Synthetism, two-dimensional/three-dimensional ambiguity, and Japonism.[37] Bates's portrait of his mother, *Marion Thomasson Bates* (1929), features saturated and, at times, Fauvist colour, spatial ambiguity, and patterning—all probably a direct outcome from his Chicago trip.

Family With Pears (1929, see p.18) goes beyond the Chicago influences; it is an important Canadian proto-Expressionist work. By giving reality and then taking away that reality (what "family"?), Bates emphatically uses Synthetism and Japonism to produce a charged social setting that emphasizes the solitude of the human condition.

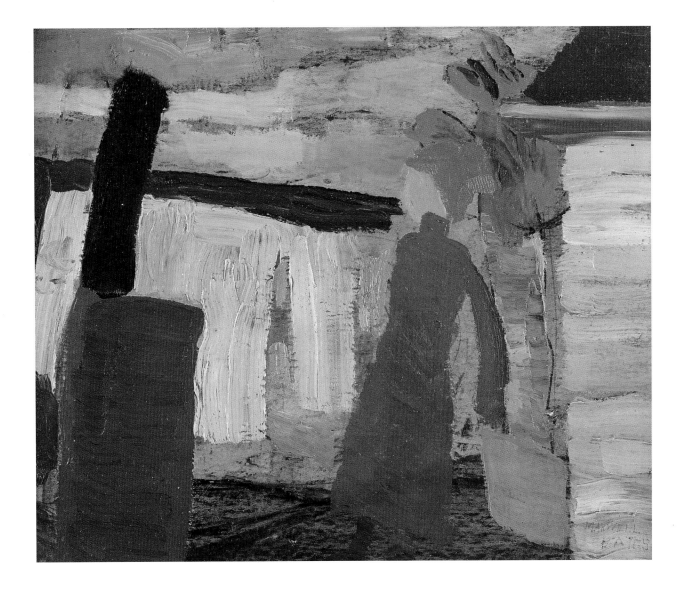

Maxwell Bates, *Washerwoman* (c. 1927)
oil on board, 19.8 x 23.0 cm., Private Collection

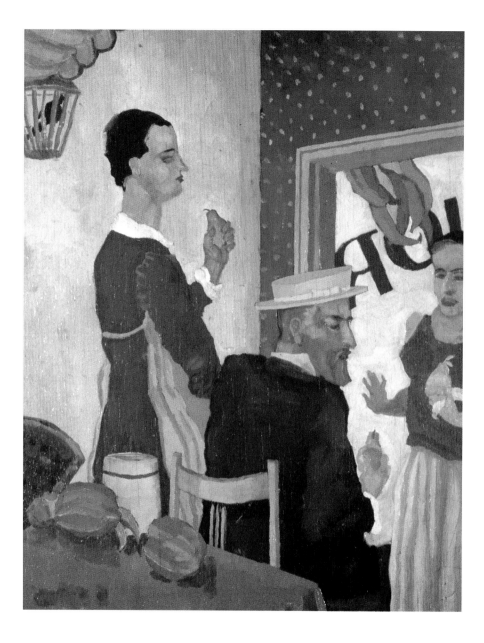

Maxwell Bates, *Family With Pears* **(1929)**
oil on board, 50.8 x 40.7 cm., Private Collection

Maxwell Bates, *Café* (1932)
pencil and watercolour, 40.5 x 33.3 cm., Private Collection

TO: MR. AND MRS. W.S. BATES
732 13TH AVENUE WEST
CALGARY, ALBERTA
CANADA

(CENSOR'S STAMP)　　　SEE INSTRUCTION NO. 2

FROM
PTE M.B. BATES
6206228 EX P.O.W
C/O BRITISH ARMY
P.L.K. REGT.
(Sender's complete address above)

My dear Mother and Dad,　　　　May 10TH.

I am glad to tell you I have been freed and am perfectly well. I am now waiting for transportation to England and will write again when I arrive.

Your loving son
Max.

HAVE YOU FILLED IN COMPLETE ADDRESS AT TOP?

REPLY BY
V——MAIL

HAVE YOU FILLED IN COMPLETE ADDRESS AT TOP?

18　　　　U. S. GOVERNMENT PRINTING OFFICE : 1945　16—28148—5

Letter from Maxwell Bates to his parents
dated May 10, 1945 announcing his freedom

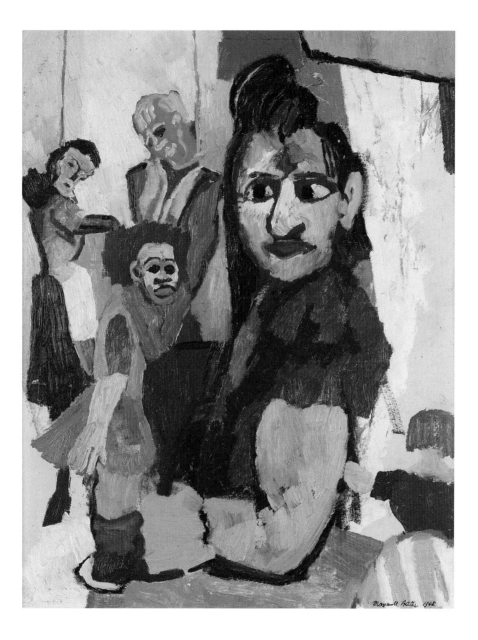

Maxwell Bates, *Puppet Woman* (1948)
oil on masonite, 49.5 x 39.5 cm., Collection of The Nickle Arts Museum, Calgary

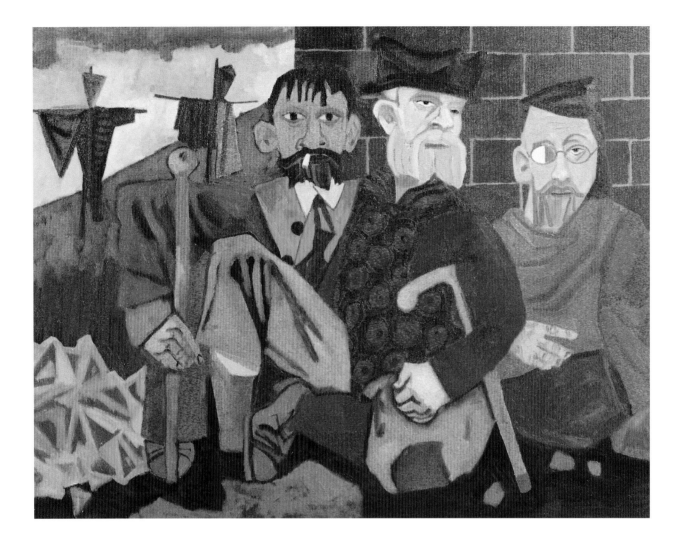

Maxwell Bates, *Beggars and Scarecrows* (1961)
oil on canvas, 76.3 x 91.4 cm., City of Calgary Civic Art Collection. Purchased with funds from the Marion Nicoll Endowment.

Maxwell Bates, *The Young Philosopher: Berlin Series* (1964)
watercolour on paper, 36.2 x 44.4 cm., Private Collection

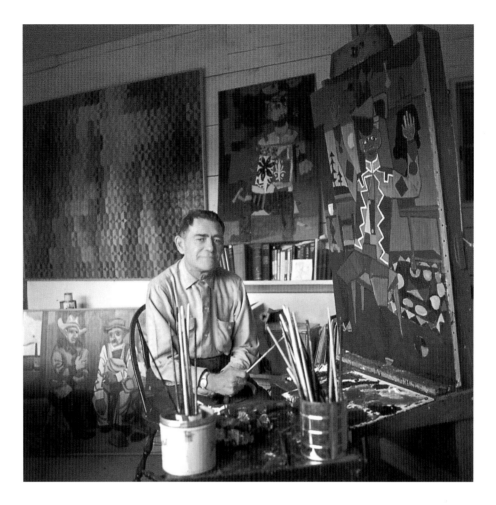

Maxwell Bates in his Victoria studio c. 1964
Maxwell Bates *fonds*, 439/89.1, Box/file 9.12 Special Collections, University of Calgary Library

London (1931–1939)

An allegorical yet autobiographical watercolour and pencil drawing, *Figure Composition* (1931), intuits the independence and freedom from his father Bates sought and achieved in London alone between 1931 and 1939. Like Picasso, who painted saltimbanque or circus figures while sorting out his family relationships,[38] Bates also paints a court jester (himself). However, unlike the jester in Picasso's harmonious scenes, such as *The Harlequin's Family* (1905), Bates's jester is defiant, no longer interested in pleasing the older authority figure (his father). The architectural reference (an early Facet drawing?) in the painting recalls Bates's apprenticeship with his father in Calgary between 1924 and 1931 as an architectural draughtsman. The classical dome separating the figures reinforces the male competition between the two. London—even during the depression—meant freedom for Bates's art, even if Bates lived until 1934 at "a subsistence level or under."

Although painted soon after, *Café* (1932, see p.19) is very different from *Figure Composition* (1931). Using simplistic Cubism Bates suggests a deliberately false perspective of an "oast house" where hops are brewed for beer in Kent. Just as in an early Paul Nash, the tree is flat and truncated. Leading contemporary British artists were draughtsmen and watercolourists who used limited space. By informing this pencil and watercolour work with mystery, danger, and freedom (the kite), Bates maintains his independence from those artists.

Within a year of arriving in London in 1931 at the age of twenty-five by cattle boat, Bates became an insider of the British art scene. Mrs. Lucy Wertheim,[39] a commercial art gallery dealer, invited him to join her Twenties Group, leading British artists in their twenties.

Among the seventy-four members were included Victor Pasmore, Barbara Hepworth, Frances Hodgkins, Robert Medley, and Kathleen Walne, and Naive artists Christopher Wood, Henry Stockley, and David Gommon. Bates exhibited with them annually in the Wertheim Gallery, 3–5 Burlington Gardens in London, as well as in Manchester and Salford,[40] and in the Wertheim Loan Collection (paintings, watercolours, and drawings) to schools. Significantly Mrs. Wertheim gave Bates two one-man shows, one in Manchester in 1934, and the other, comprised of thirty-three works, in London in November 1937.

Mrs. Lucy Carrington Wertheim,
Bates's commercial art gallery dealer in the '30s
photo by Lafayette, published in Lucy Carrington Wertheim,
Adventure in Art, (London and Brussels: Nicholson and Watson, 1947)
photo courtesy Lucilla and Philippe Garner

Bates's one-man show,
Wertheim Gallery,
London, 1937

Wertheim Gallery
8 Burlington Gardens, W.1

PAINTINGS BY
MAXWELL BATES

1. Rue Jules Cesar	..	20 gns.
2. Country Folk	..	15 „
3. Figures	..	10 „
4. Place de la Bastille	..	8 „
5. Public Garden	..	10 „
6. Summer Evening	..	8 „
7. Boys on the Heath	..	20 „
8. Afternoon	..	8 „
9. Studio Interior	..	20 „
10. Beach	..	7 „
11. Road in Heyst	..	8 „
12. Rue Clovis	..	20 „
13. Richmond Park	..	15 „
14. Sawyers	..	10 „
15. Interior	..	—
16. The Studio	..	12 „
17. River Scene	..	20 „
18. Cafe	..	7 „
19. Turkish Interior	..	10 „
20. The House	..	8 „
21. Boulevard Bolwerk	..	7 „
22. Road in Brussels	..	8 „
23. The Attic	..	5 „
24. Cafe Interior	..	10 „
25. A Game of Chess	..	10 „
26. The Cottage	..	15 „
27. The Workman	..	15 „
28. Three Men	..	10 „
29. Norfolk Landscape	..	10 „
30. The Pathway	..	10 „
31. The Washerwoman	..	10 „
32. At the Fair	..	10 „
33. The Revellers (Drawing)	..	7 „

From fellow Twenties Group member C. Nesbitt, Bates may have learned unusual coloured shading; he likely admired members such as John Melville for his architectural and tonal work, David Gommon for his theatre and ballet scenes, and George Bissell for his workers. Bates attended the openings for the ninety-seven shows Mrs. Wertheim organized between 1930 and 1939 in her London gallery.

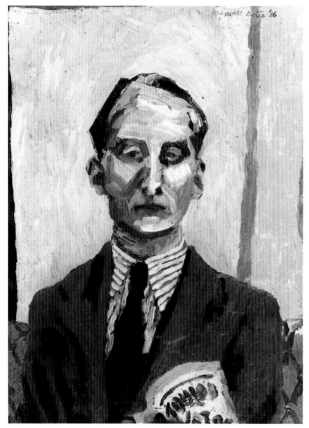

Maxwell Bates, *Portrait – Sir Brinsley Ford* **(1936)**
oil on board, 40.6 x 35.6 cm. Collection of the late Sir Brinsley Ford.
Photograph courtesy: Photographic Survey, Courtauld Institute of Art
with permission of the Sir Brinsley Ford family

Besides Samuel Courtauld, George Bernard Shaw, and others,[41] Wertheim's clients included Sir Brinsley Ford, a future trustee of the board of the National Gallery, who commissioned Bates to paint his portrait in 1936 for ten pounds. Interestingly Bates may have seen Ford's fourteen Punchinello wash drawings by Tiepolo —Bates revelled in London's Punch and Judy plays and prints—and Ford's mysterious *The Yellow Man* (1930) by Christopher Wood[42] while working on Ford's direct and colourful portrait. Villiers David also commissioned a portrait and shared an interest in Japanese prints .[43] Altogether, Villiers David and Ford bought eighteen Bates paintings.[44] Bates's record book of sales indicates he sold sixty-four artworks between 1932 and 1939, most often for a pound each, although Bates claims in his biography that the Wertheim Collection held 60 of his paintings.

Bates's only other source of income between 1931 and 1934 in London was from selling vacuum cleaners and water softeners. Given Bates's taciturnity and London's depression these proved meagre. In 1934 he secured a position as architectural assistant to J. Harold Gibbons out of London until 1939.

Five-sided box with Japanese subjects, **(1938)**
Gouache on paper. Commissioned by David Villiers, London.
From old photograph, Maxwell Bates *fonds*, 439/89.1, Box/file 16.1
Special Collections, University of Calgary Library

Bates learned of other artists besides himself seeking freedom for their art in London from 1933 on. Modern artists and architects escaping cataclysmic Nazi persecution in Germany started to arrive in London. After becoming Chancellor on 30 January, 1933, Hitler began his campaign to rid Germany of Jewish and modern art instructors, museum directors, artists, modern art and art by Jews. These emigres included Walter Gropius in 1934, Laszlo Moholy-Nagy and Marcel Breuer in 1935, and Oskar Kokoschka in 1938. One of the last shows Mrs. Wertheim held in her gallery was a Refugee Artists Show, the *First Group Exhibition of German, Austrian, Czechoslavakian painters and sculptors* sponsored by the Free German League of Culture in England during June–July 1939.

Bates, when asked in 1972 whether he "had [you] come across the German Expressionists before that point [World War II]?", replied:

> **Yes, certainly. A great deal in books and also in exhibitions in London...Beckmann, you could see quite alot of reproductions in those days. I was always checking on those; there was always very good colour and very subtle.**[45]

Bates admired Beckmann's direct and expressive brushwork.

Bates likely absorbed Herbert Read's chapter on "Expressionism: The Theory of Subjective Integrity" in Read's *Art Now* published in 1933. Bates read, reacted, and even had his replies to Herbert Read's writings published.[46] Read championed Expressionism and defined it as: "art that depends for its subjective appeal, not so much on formal elements, as on the emotional content of the objects or events represented."[47] Expressionism, according to Read, was "a means of communicating the emotions which the artists feel with overpowering intensity."[48] Expressionism brought emotional unity to a work of art, even "transcendentalism and psychological content."[49] Empathy, or the theory of *Einfühlung*, enabled a viewer's "feeling into" to take place in the aesthetic appreciation of an artwork. Read believed Max Beckmann, Otto Dix, and George Grosz had created a realism "which is partly... a protest intensified by the experience of war...The phrase *Die neue Sachlichkeit*, 'The New Objectivity', was coined to describe them...."[50]

Bates also likely read formalist Roger Fry's negative review[51] of Read's *Art Now* in the *New Burlington* magazine in May 1934. Fry upheld plastic unity: "Latin artists do not really break with the European tradition of the past...their constructions have plastic unity and significance, whilst the Germans lack this quality almost entirely and do in fact go straight back to their own expressionist ancestry."[52] And: "Mr. Read's explanations, however, do seem to me to remain in a region of psychological speculation far removed from the actual sensual qualities of the works in question."

By 1934, Bates championed Naive Painting, with its Expressionist underpinnings, in his article published in a Wertheim publication titled *Phoebus Calling*:

> Naive painting is more emotional than painting built on a theory or method invented by the intellect, and this lack of an accepted method or theory has the virtue of allowing it to be intensely individual; full of the personality of the painter. An instinctive rather than a reasoned placing of the parts of the picture gives a sense of order to this painting...The naive painter is a Humanist making plastic comments on the residue of daily life.[53]

Bates illustrated this article with art by fellow Twenties Group artists Christopher Wood (admiring Wood's "patterns, rich colour" in his ship/townscape painting), Henry Stockley ("unusual arrangements of deep colour"), Vivin ("decorative value of brickwork and stone"), as well as his own art.

But *The Times* in 1934 considered Bates's landscapes in a different light. "[T]hough simple enough, [they] can hardly be said to be naive...."[54] A writer for *The Times* in 1935, for a review of *Some Modern Primitives*, declared: "I cannot consider Maxwell Bates as an innocent at all."[55]

Bates's art of the 1930s is stylistically diverse, but gradually content and subjective feeling superseded form (coincidentally with Roger Fry's passing). *Working Man* (1933) shows sympathy for the worker and nostalgia for North America. Ben Shahn posters, or reviews of his art, in London may possibly have been an influence on Bates. By 1937 Bates had painted *Man With A Pipe* in an Expressionist style. The partially darkened face recalls Max Beckmann.[56] The large hands and exaggerated stance evoke empathy for the subject. Bates was readily achieving personal expression in his art in London.

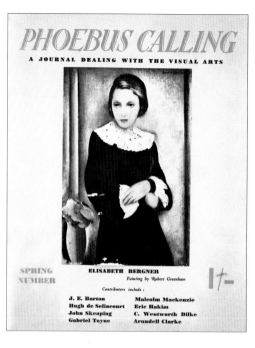

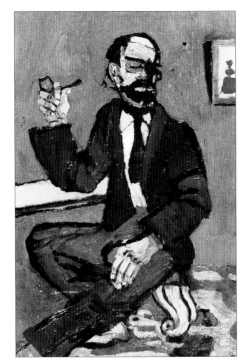

Maxwell Bates, *Man With A Pipe* (1937)
oil on cardboard, 29.2 x 47 cm.
photo, Maxwell Bates *fonds*, 439/89.1, Box/file 16.1 Special Collections,
University of Calgary Library

Maxwell Bates,
"Naive Painting,"
Phoebus Calling
(a Wertheim publication),
(spring 1934): 20–23

Unit One, a British modernist group of eleven artists including Henry Moore, Barbara Hepworth, Paul Nash, Ben Nicholson, and Ed Burra, also sought freedom for art. Formed in 1933, Unit One embraced art, design, and architecture, three of Bates's main interests. The group's organizer Paul Nash, set out Unit One's mission: "Unit One stands for the expression of a truly contemporary spirit, for that thing which is recognized as peculiarly *of to-day* in painting, sculpture and architecture."[57]

Of the Unit One artists, "the romantic grotesquerie of Ed Burra's art fascinated him [Bates]"[58] as well as Burra's Expressionist content. Like Bates's later art, "Burra's work had premonitions of the breakdown of order ahead."[59] Burra's interest in complex social interactions, especially from popular culture, and setting up a paradox between reality and imagined space also appealed to Bates. Both Burra and Bates were moralists, interested in exposing real life. Burra, in turn, admired George Grosz's art. Grosz "was concerned with the unmasking of the conventionally disguised relationships of sex and money in public settings...."[60] The ambiguity of the two main figures' underlying sexual relationship in Burra's *The Snack Bar* (1930)[61] relates to the complex social interaction in Bates's Cocktail Party/Reception series of the 1960s and 1970s. In the early 1930s Bates also admired Paul Nash's art,[62] its simplicity, and the work of Edward Wadsworth and Walter Sickert.

By 1935 the Artists International Association (AIA) began to concern itself with the fight against Franco's fascist forces in Spain. Bates exhibited with AIA artists in London. On a trip to Paris in 1937 Bates found Picasso's socially-engaged painting, *Guernica*, to be "a revelation."[63] He saw it again in 1938 in London with its sixty-seven preparatory paintings, sketches, and studies at the New Burlington Galleries. Socially-engaged painting was becoming increasingly relevant to Bates.

In 1937 Bates exhibited two Expressionist works in the AIA exhibition, titled *Unity of Artists for Peace, Democracy, and Cultural Development*, in London. The exhibiting artists were responding to Hitler's Aryan ideal and the Nazis' ruthless suppression of Modernism that "uses the individual as a standard by which and a point of reference from which to experience reality"[64] and of individual subjectivity. Instead the AIA argued for freedom for art and plurality of expression. In this show Maxwell Bates, this rare Canadian artist, exhibited alongside Matisse, Picasso, Kandinsky, Moholy-Nagy, Ben Nicholson, Miro, Ernst, Klee, Giacometti, Henry Moore, and others.

20th Century German Art opened at the New Burlington Galleries in London in July 1938 as a reaction to Hitler's Degenerate Art show touring Germany.[65] The London show consisted of 270 works by fifty-three modern German artists. The Nazis had banned these artists' works in Germany since 1933 for their modernism and their uncharacteristically German qualities. In the catalogue's "Introduction," Herbert Read upheld true German art and especially German Expressionism and the principle that art should be free:

> But just when the moment seemed propitious for a more active interchange of ideas, German art was swept away in the country of its origin, condemned on political grounds and ruthlessly suppressed. The artists themselves either fled into exile or were compelled to abandon their creative activity.

> The [Exhibition's] organizers...affirm one principle: that art, as an expression of the human spirit in all its mutations, is only great in so far as it is free...the most characteristic type of modern German art demands and has received a special name, Expressionism; and that this type of art is in essential conformity with the historical tradition of German art—the art of Cranach, Altdorfer, and Grunewald.[66]

Artists International Association, *Unity of Artists for Peace, Democracy, and Cultural Development* exhibition 1937

Bates probably attended the opening of *20th Century German Art* (appeasement title) where the great German Expressionist (and his future instructor) Max Beckmann gave the opening address on 8 July, 1938. Organized by Herbert Read and others, the exhibition featured art by Max Beckmann, Paul Klee, Kathe Kollwitz, Ernest Barlach, Otto Dix, George Grosz, Wassily Kandinsky, Ernest Kirchner, Oskar Kokoschka, Franz Marc, Emil Nolde, Max Pechstein, and Paula Modersohn-Becker. It is likely Bates read the show's reviews.[67]

Bates probably admired the show's *The King* (1937) by Max Beckmann (see below); he kept a reproduction of it in Canada. In this painting, and like Ed Burra, Beckmann conveys the breakdown of social order. To quote Carla Schulz-Hoffmann:

> the King's legs open up defensively...he no longer finds protection within the security of the pictorial composition but is at the mercy of whatever exists outside...perhaps the king is a self-portrait...The dangers encountered by the artist, a king in fool's clothing, have been escalated by National Socialism...the painting becomes a metaphor for the existentially threatened artist....[68]

Installation view of the 'Exhibition of Twentieth Century German Art', New Burlington Galleries, London, July 1938. photograph by Ewan Phillips with kind permission of widow of Ewan Phillips, Photo Tate Archive.

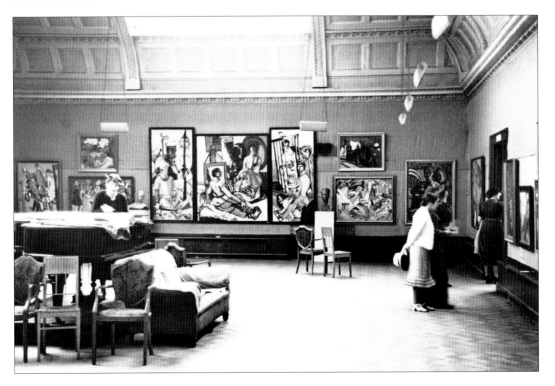

While Bates's later iconography of a beggar-king is original,[69] Beckmann "king in fool's clothing"[70] shares affinities with Bates's beggar-king. (Bates later took a course from Beckmann for four months in New York from 1949 to 1950.)

In his search for what is real, Beckmann's address, titled "On My Theory of Painting," which was translated into English immediately after, must have held great meaning for Bates who probably heard or read it in reviews.[71] Beckmann declared:

> I have tried only to realize my conception of the world as intensely as possible.
>
> What I want to show in my work is the idea that hides itself behind so-called reality. I am seeking the bridge that leads from the visible to the invisible....
>
> My aim is...to make the invisible visible through reality. It may sound paradoxical, but it is, in fact, reality which forms the mystery of our existence.[72]

Like Bates, Beckmann believed in the self and upheld unity of opposites. Instead of condemning the Nazis publicly in London, Beckmann quoted the British Romantic William Blake.

Similarly, Bates affirmed humanity in his poem "No Man Is Wholly Bad" in 1938, writing:

> No man is wholly bad
> Till every man draws back
> From every other
> And dies.
> The cruel, and those
> Who pass by on the other side:
> As much as they
> We are to blame.
> The shame belongs to us:
> Those who are degraded
> And those who degrade
> Are equal
> In being men.
> We share the shame
> For we are all the same.

Two days after Britain declared war, on 5 September, 1939, the Wertheim Gallery[73] was closed and converted into an air-raid shelter.

During his ten years in London Bates managed to see some two thousand art exhibitions. The subjective ideas and emotions in German Expressionists' art in London in the 1930s and the break-down of social order and visual possibilities of ambiguity in complex social interactions in Ed Burra's art must have struck an accord with Bates. Though these ideas for serious painting lay latent for several years, Maxwell Bates, the truly great Expressionist in this international context, was about to emerge in a most extraordinary way.

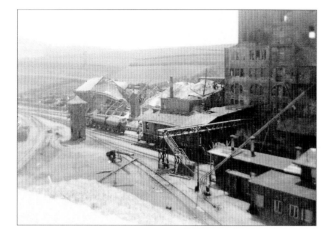

Prison camp,
a salt mine, Stalag IXC, Unterbreizbach, Germany where Bates was imprisoned from 25 July 1940 to 31 March 1945.

Maxwell Bates,
Prisoner of War Notebook, 1940–
Maxwell Bates *fonds*, 439/89.1, Box/file 15.1
Special Collections, University of Calgary Library

Bates's Prison Number: 1697
Maxwell Bates *fonds*, 439/89.1,
Special Collections,
University of Calgary Library

Prisoner of War, Germany (1940–1945)

In April 1939 Canadian artist Maxwell Bates volunteered and joined the Princess Louise machine-gun battalion of the Middlesex Regiment of the British Territorial Army to help fight the Nazis. On 12 June, 1940 private Bates, along with the remnants of the 51st Highland Division, part of the French IX Corps, was captured by the Nazis at St. Valery-en-Caux on the west coast of France.[74] On starvation rations, Bates survived the first forced march to near the Belgium-Holland border, he was then taken by open railway cars and barges, both carrying coal, and overcrowded closed railway cattle cars (without sanitation or ventilation) to Unterbreizbach, Germany. There Bates was held captive at Camp Arbeits Kommando 137, Stalag IXC, a salt mine, for five years, from 25 July 1940 to 31 March 1945.

There, also, Bates defied Hitler and the Nazis by maintaining his intellectual freedom as an artist. He secretly kept a notebook full of supreme artist's subjectivity. "I valued it highly."[75] It is an extraordinary Romantic treatise on the nature and function of art. It is also an important private act of resistance in that it assumes that all men and women are equal regardless of religion, race, or nationality. There is a certain urgency to it. Miraculously it has survived.[76]

Deprived of making serious art and forced to experience war from the inside as a prisoner of war, Bates transformed his Expressionist and Romantic sources of creativity into his Prisoner of War Notebook. In it, Bates—now number 1697—argued for the primacy of the visual arts and rhythm, and "saw the universe as a unified whole."[77] At times Bates sounds like a mystic. Nowhere in Part I or in the forty-five page Part II of the carefully handwritten Notebook does Bates mention his prison circumstances.

Part II[78] records much of Bates's original ideas on art and humanity:

> **Beyond** the Self and Space and Time is the goal of man's spirit. To reach this state is the ultimate purpose of artistic and moral development.[79]
>
> **The reason** for the manifestation of art is the desire to escape from the rigid framework of space & time. The creation & appreciation of art does allow this escape to take place. All works of art are timeless & spaceless insomuch as they are eternal and, at least, partly free from any one moment of time; *they reveal the universal in the particular* and therefore cannot belong entirely to any one position in space...
>
> The means of achieving this end are rhythmic. *Rhythm is the quality which can dilate the present to contain eternity & which can hold the universe in the space of a figurine or a sheet of paper.* The artist finds the universe full of similarities, parallels, rhythms. He is synthetic in outlook, as opposed to the scientist who notices the differences in things & is analytic in his approach to the natural world ...The similarities and parallels that the artist selects and records from the great maze of phenomena and apparent chaos of the universe are rhythms and form the basis of order, the elements of artistic organization and composition.[80]
>
> **...the quality** of art is not a material thing but must be held in a material form to be perceived or known by each spectator.[81]

Bates started to jot down these remarkable statements in Hell's Kitchen (Hotel Eichenbaum) in Bad Sulza, the administrative centre for Stalag IXC, just after the first forced march and just before being sent to the prison camp in Unterbreizbach. No other notebook by British POWs in the Second World War currently preserved in the Imperial War Museum[82] in London even comes close to displaying the philosophical and unitary nature of Bates's POW Notebook. On its own or as an Expressionist document, it is of international significance.

Bates wrote most of the Notebook at Camp 137 after he survived eight-hour labor shifts on the transport gang. At rifle point he was forced to work from 5:15 AM to 1:45 PM, seven days a week for almost five years. This was, of course, in direct contravention of the Geneva Convention. In *Wilderness of Days* Bates recounted his true working conditions:

> One of our worst and most frequented work places was the Schrottplatz. This scrap-iron yard was a dump of old valves, pumps, steel plate, iron wheels, broken cast-iron and machinery to be loaded into railway coal cars. Filling *Schrottwagen* was a transport job, as was taking the scrap to the dump. We filled two or three coal cars a week, sometimes for months on end, in all seasons. A car was full if it weighed twenty-two tons when pushed by our shoulders onto the weighing machine....[83]

Bates endured this tension between heavy labor and philosophical thoughts about art for five years, even writing about love under these conditions. Bates was aware of Lipps's doctrine of *Einfühlung* (empathy) to explain love. In the persona of Gamma, an artist, Bates wrote:

> 'A feeling into' expresses the idea closely, if awkwardly, in plain words. It is momentary state of mind...in which one becomes sympathetically (more correctly empathetically) a part of something outside the Self. One has the sense of a greater reality than that apprehended in everyday life. (expansion)[84]

Astonishingly Bates transformed ostensibly an experience of exile—Bates, a rare Canadian[85] in an international community of POWs—into a unitary one by reaching deep within Western philosophical thought to universal ideals and truths. The Notebook became Bates's way of feeling free. It definitely helped Bates survive: the Nazis could weaken his body but not his mind nor spirit, he resolved.

spatialization of Time as an instinctive activity of man was first completely shown me by Aldous Huxley's 'Beyond the Mexique Bay' although I had known that man felt it necessary to mentally reach some position beyond space and time, at least for short intervals of release given by his perception of rhythm. As he writes, 'The endless continuity of Time is appalling; arbitrarily therefore, men parcel up the flux into sections.' The bonds of space may also be appalling, if to a lesser extent. Music effectively divide the endless continuity into recurring spatial sections and its rhythm has done much to satisfy mens' craving to escape, while it lasts, beyond Time. That music is effective is a proof that the bondage of space is more bearable because music has no means of lifting us out of the place we happen to occupy in the universe. The existence of the visual arts, however, shows our need to fly both prisons. That the visual arts are less popular and less understood than music is well known, their service is less necessary in proportion as the mind is less developed, and therefore less sensitive to its surroundings. For unimaginative people it is sufficient to escape the realization of time. Highly developed man must escape beyond space and time. The visual arts effect an escape from both at once.

Beyond the Self and Space and Time is the goal of man's spirit. To reach this state is the ultimate purpose of artistic and moral development. Religion serves the same purpose. This state, however, is unimaginable, unknowable, in any completeness, simply because man cannot imagine or know anything spaceless and timeless. Any concept whatever that is man's is conditioned by space and time. Therefore he must use them in his attempt to escape beyond them and any construction of his imagination and intellect such as theologies and philosophical explanations of ultimate reality must be untrue except inasmuch as they may have some metaphysical parallel, symbolic relations with the unknown original. However, they have the purpose of relieving the pressure of space and time, that claustrophobia caused by being always in one place at one time may be more or less defeated or kept at bay although the transience of each state of mind thus reached bears within itself a sadness caused by its realization, a sadness the Romans called 'lacrimae rerum' and which informs every great work of art. Nostalgia, which is merely a desire to escape ones own position in time for some other, is

The reason for the manifestation of art is the desire to escape from the rigid framework of space & time. The creation & appreciation of art does allow this escape to take place. All works of art are timeless & spaceless insomuch as they are eternal and, at least, partly free from any one moment of time; they reveal the universal in the particular & therefore cannot belong entirely to any one position in space.

If the analogy may be permitted, the bondage of space & time produces claustrophobia which in turn forces the artist to create and other men to turn to works of art. The definite and noticeable melancholy which is in most great works of art, that sense of the 'tears in things' of the Romans, that all artists have, is 'nostalgia' the desire to break through space & time.

The means of achieving this end are rhythmic. Rhythm is the quality which can dilate the present to contain eternity & which can hold the universe in the space of a figurine or a sheet of paper. The artist finds the universe full of similarities, parallels, rhythms. He is synthetic in outlook, as opposed to the scientist who notices the differences in things, & is analytic in his approach to the natural world. Parables & metaphors form rhythms with what they represent, they are inexact images, as it were translated images. All creative rhythm is a series, each unit of which is similar but not an exact reproduction of any other. Thus the metaphor, the creation of which marks the great poet is itself rhythmic, apart from the obviously rhythmic nature of metre. The similarities & parallels that the artist selects & records from the great mass of phenomena & apparent chaos of the universe are rhythms & form the basis of order, the elements of artistic organisation and composition.

How many of the great artists of the world have conceived their works in unhappy circumstances, in prison, exiled, in extreme poverty? The answer, while proving nothing illustrates the idea of the importance of nostalgia in the creation of art. Bunyans' 'Pilgrims Progress' was written in Bedford Goal, Marcel Proust wrote 'La recherche du temps perdu' while a bed-ridden invalid. Dostoievski conceived many of his works in Siberia.

All those who have not the artists gift of rhythmic creation or appreciation, or in whom these things are underdeveloped, yet have their means of escape in the day dream, in the cinema, in the novel of romance or adventure. At the present time many young girls prefer to be factory workers to being domestic servants because their monotonous jobs in the factories do not occupy their minds enough to prevent them spending the hours in day-dreaming & reverie.

Maxwell Bates,
Prisoner of War Notebook, 1940
Maxwell Bates *fonds*, 439/89.1, Box/file 15.1
Special Collections, University of Calgary Library

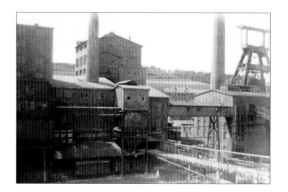

Prison camp,
a salt mine, Stalag IXC, Unterbreizbach, Germany,
where Bates was imprisoned from 25 July 1940 to 31 March 1945.

In her examination of the Notebook, University of Calgary's Professor Emeritus of Philosophy, Petra Von Morstein, remarked:

> Bates' distress of war imprisonment is conjoined with his artistic creativity and thus with the transforming power of art. This conjunction engenders insights which integrate art, metaphysics, and ethics into a unity. This puts Maxwell Bates in the company of philosophers such as Schopenhauer, Nietzsche and the early Wittgenstein.

> ...if we read the Notebook as a document of the lived practice of philosophy: [then it becomes] Philosophy as immediate self-expression and active transformation of suffering. Bates' view of the world as rhythmic unity is then to be understood as a source and instrument for integrating injustice and suffering in the whole of reality and thus transforming and transfiguring the individual experience of suffering.[86]

As Bates acknowledged: "I valued it [the Notebook] highly."[87] To ensure its survival against Nazi Kontrol raids, Bates applied in 1943 to have it censored and stamped by the Nazis at Bad Sulza. By then he had written most of Part II. As a civilian thirty years later Bates recalled:

> My Prisoner of War experience intensified my art ...because I had been thinking so much about it all the time...I wanted to do things as simply and directly as possible and I've never changed from that idea.[88]

In prison, because "there are always too many people about to do any serious painting,"[89] Bates nonetheless explored a few of the "seeds planted in the London Art Galleries."[90] His major theme of puppets in his later work began with the seven puppets he designed and operated for the Christmas Punch and Judy show in 1942 and 1944. His interest in painting gypsy caravans first began when he painted the background for a musical in September 1943. He pursued his unbounded interest in figurative work, completing his twenty-fifth pencil portrait of his fellow prisoners within two years of captivity. In the hospital recovering from damage caused by wooden slivers in his bread, Bates was fascinated by a Serbian POW, Chopanov. For the first Christmas entertainment in 1940, Bates created the poster: "March, Melody, Macabre." He drew sketches of the countryside with notations for colour and value when he could. Bates carved his own chess set out of wood. He wrote poems, such as "Barbed Wire" that "reveals his sense of inner freedom"[91] and "Behold The Flowers."

From Bates's letters to his parents in Calgary from the prison camp, we learn of his steadfast relationship with them during his ordeal. Upbeat, never displaying self-pity, the informative 142 postcards and fifty-five letters rarely reveal Bates's actual working conditions, as were related in *A Wilderness of Days*.

In the POW camp Bates learned to veil reality with appearances in the censored letters he sent three times per month for five years. In the letters from his parents and siblings, which he did not receive for months, he learned to unveil appearances with reality, viz. his parents' boundless love for him. Thus his keen lifelong interest in appearance and reality, observer and observed, were strengthened. "Appearance and Reality" is a chapter in the Notebook: "everywhere there were spies."[92]

A strong wind sings in the barbed wire:
I hear
The menace of their interplay.
The wire
That tears the flesh away
Cannot stay a fragile butterfly;
Or hold man's weak spirit, stronger yet
than clay.
And the poet in his eternal dream
Knows but a wandering zephyr in the fell
barbele.

Maxwell Bates, "Barbed Wire," poem, POW Notebook
Unterbreizbach, Thuringia, Germany, 1943

Prisoner Of War letter to his parents
dated March 25, 1943

Seven years after the Nazis burnt books by Jewish writers such as Bertolt Brecht and Sigmund Freud in Berlin, this Canadian prisoner of war read at Stalag IXC books on Western philosophy and art, modern poetry and Shakespearean plays that he requested from his parents in November, 1940 and received.[93] A year later, he requested books on painting, architecture, poetry, history or philosophy, very modern poetry and psychology. Bates was a valued member of "Stube 5," a group of men who were regarded as the intellectuals of the prison camp.

Overall Bates's manual work at the salt mine greatly increased his knowledge of men at work. Bates's post-war Prairie People series, his paintings *Workmen – Lunch Hour* c. 1957 and *Workmen* 1957—all reflect Bates's abiding interest in this theme. Portraying worker's hands and feet as credible became important for Bates.

The critical stimulus for Bates's most profound Expressionist prisoner of war-related artwork occurred during the six weeks of his second forced march in April 1945. He saw thousands of Jewish survivors of Nazi concentration camps in a

> column (that) had a horrible, staggering, halting rhythm. The column was like a multitude of puppets.... Those moonlight ivory faces expressed courage, fear, ferocity.[94]

Soon after he heard several hundreds being shot. His compassion and empathy reached a new level. On his release on 3 May, 1945, and while still in Europe, likely England, Bates began painting his subjective response to these "political or civilian prisoners"[95] giving them dignity, a sense of resolve while at the same time maximizing the expressive power of stripes, chunky wooden shoes, gnarled hands, and wide-eyed god-like faces. Maybe they are the genesis for Bates's later beggar-kings?

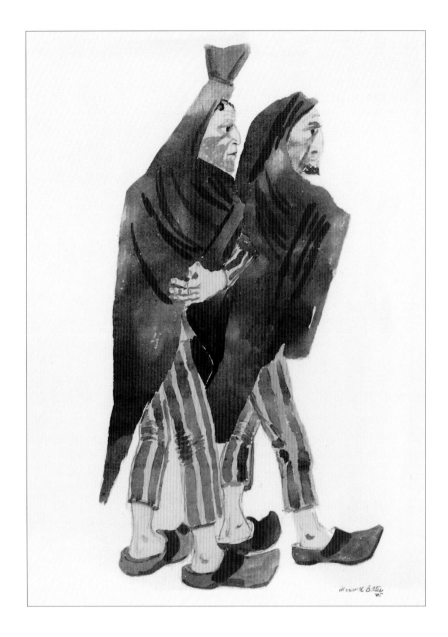

Maxwell Bates, *Civilian Prisoners,* Germany (1945)
watercolour, 22.9 x 30.5 cm.
photo, Maxwell Bates *fonds*, 439/89.1, Box/file 16.3,
Special Collections, University of Calgary Library

Part II

Civilian Prisoners (1945) is at the very heart of Maxwell Bates at the crossroads of Expressionism. It shows the direction Bates would pursue in Canada. On liberation, fundamentally Bates's five-year POW experience released his acute awareness of man's inhumanity to man.

Against the backdrop of Bates's later entries from Cyril Connolly's *Unquiet Grave*[96] where Connolly questions what gems of Western thought are left after World War II, we have noted Bates recorded in his Notebook this important paradoxical idea: "Rhythm is the quality which can dilate the present to contain eternity & which can hold the universe in the space of a figurine or a sheet of paper."[97] In the character of Alpha, a philosopher, Bates explored the meaning of his theory about the "dilation of the present" eighteen pages later, when he applied it not only to art but also to the universal concepts of indivisible wholeness, unity and [God stuck out] Goodness.

> The <u>dilation of the present</u> then, requires an almost perfect functioning of the parts of the mind, so that they become one indivisible whole. So complete must be their organization and co-relation that they interfuse in a rhythmic movement towards the underlying unity which is ultimately, the goal and end of movement and to reach which is the universal purpose. It is a movement towards the Good [God struck out].
>
> The <u>dilation of the present</u>...is the basic reason for the inequality of man. Perhaps it is the only valid reason, for it springs from the source of all ethical value.[98]

This Rhythm statement and his restating in 1949 that "*My wish has always been to reveal underlying universal qualities in the topical and particular*"[99] offer the keys to our understanding of Bates's post-war Expressionism on his return to Canada in January 1946. Through rhythm, certain personally meaningful "universal qualities" or universal truths underlying the "present" or "particular" could be revealed "to contain eternity" and, at the same time, "hold the universe in the space of a figurine or a sheet of paper."

Calgary, Canada (1946–1962)

Environment and its Effect on People: Bates's Prairie People Paintings

What differentiates Bates's first significant body of work—his Prairie People paintings—on his return to Canada in January 1946 from his London works in the 1930s, but is profoundly similar to *Civilian Prisoners* (1945), is his new emphasis on the effect of environment (the Canadian prairies) on people. This would be one of Bates's defining characteristics as he continued to invent Expressionism in Canada. Through this intuitive realization Bates made manifest his POW theory on dilation of the present. The liberated POW artist Bates could identify with the effect of environment on peoples, now in a Canadian prairie context, both in his art and in his writings, especially his article titled "Some Problems of Environment"[100] (1948).

In his Prairie People paintings Bates also expresses his empathy for the hard-working life of the Canadian prairie people, their steadfast determination to survive. Bates experienced similar hardships when he worked as a manual laborer for five years in the prison camp. His social conscience led him to humanize and champion them, giving them dignity in their severe environment.

Roy Kiyooka described Bates's Prairie People artworks as "among the truest i have of the Foothills and the Prairies."[101] Certainly they constitute an important aspect of Bates's Expressionist legacy to Canadian art. They brought Bates national attention.[102]

Prairie Woman (1947) stands as a Western Canadian icon. A product of the harsh Canadian prairie environment, this determined woman stands resolutely against the wind, her face, extended large right hand, firm legs, and shoes all telling indicators that she will triumph against any prairie adversity. It is a profound Canadian Expressionist work. In *Prairie Settlers* (c. 1947) Bates gives an elderly European prairie couple presence by bringing them close to the picture plane. In *Prairie Family* (1960) Bates uses the rhythm of vertically stacked horizontal and vertical stripes arrested by the woman's misshapen hand, universalized figures tightly packed in shallow space, and sombre colours to emphasize the effect of prairie deprivation and the rigours of family life on this woman. In *Farm People* (1967), Bates inexorably integrates colourful figural and landscape components for overall pictorial unity.

How wrong Toronto-based Barker Fairley was in 1948 when he deplored the lack of the human figure in Canadian art in his article titled "What is Wrong with Canadian Art?."[103] Fairley seems unaware of the Prairie People paintings by Calgary-based Bates.

Jock Macdonald,[104] Bates's new friend in Calgary in 1946, was far more insightful. From Toronto he wrote to Bates:

> Who ever said that your work had heaviness and brutality? This is not true. Certainly it had a severity and solidity. The severity was true, for me, to the climatic characteristics of the people in Alberta, where one would never find a classical mould....I found your sensitivity and forcefulness of statement a most unique quality—exceedingly personal, decidedly art and a vital contribution for all of us to experience.[105]

Because of Bates's compassion and empathy, he identified with the effect of environment—the Canadian prairies—on people. This was the first meaningful universal truth or "universal quality" Bates explored within the Expressionist canon in several paintings in a post-Second World War Canadian prairie context. Indeed, much of Bates's later art, such as the cocktail parties, can be considered as Bates's reaction to, and statement about what is real in his environment.

Calgary (1946–1962) & Victoria (1962–1980)

⊕ Bondage and Freedom Within the Human Condition

Underlying the effect of environment on people is the more fundamental "universal quality" or universal truth of bondage and freedom within the human condition. This quality is found in much of Bates's post-Second World War Expressionist art in Canada and particularly in his puppet/scarecrow/crucifixion works. Through this universal truth Bates made manifest his POW theory of dilation of the present. Bates's Prairie People paintings can be considered prototypes for these works.

Puppet Woman (1948, p.21) is a profound Canadian Expressionist masterpiece. It unifies Bates's British and prisoner of war experiences, while at the same time releases him from the coordinates of Canadian prairie place and space to the more universal and elemental human condition. The intensity of expression in this work, the unequivocal message of domination over those controlled, remain unparalleled in mid-twentieth century Canadian art. With *Puppet Woman*, Bates had arrived at one of his essential messages: "Man is manipulated by forces over which he has no control."[106] Bates's Punch and Judy puppet shows in the prisoner of war camp take on new meaning, as does his comparison of the Nazi concentration camp survivors of 1945 to puppets and Bates's admiration for Samuel Beckett's writings around 1948. Considering the fact that Bates arrived in Calgary in January 1946 "a very unsettled man"[107] and his initial non-prairie art was tentative, *Puppet Woman* (1948) is brilliantly cohesive in content and composition. It was painted before his four-month course with the great German Expressionist, Max Beckmann, in New York during the winter of 1949 to 1950. (To keep complete independence for his art Bates had resumed work in 1946 as a full-time architect in his father's office.)

The watercolour[108] *Puppets* (1955),[109] with its inexorable Punch and highly integrated layered figure/ground, is far lighter in tone than *Puppet Woman*. It received honourable mention in the Montreal 1957 Spring Show and was reproduced in the *Montreal Star*.[110] Punch and Judy themes continued such as in the ink and watercolour *Marionette Play* (1974) and the lithograph *Punch and Two Others* (1977), as did puppets such as in the oil *West Indian Puppets* (1972), with its three looming abstracted puppets.

Around 1948 a scarecrow[111] first appeared in Bates's art:

> the scarecrow became a symbol of the condition of man in the 20th century… That relates it to puppets and marionettes which I've often used as subjects also. All these are moved by unpredictable outside forces.[112]

This quote explains the new compatibility between beggars and scarecrows that surfaces in Bates's work. *Beggars and Scarecrows* (1961, p.22) also shows the development of Bates's beggar theme, which first appeared in 1958. Bates's allegory of Beggar-kings ("I've always been interested in opposites…"[113]), starting around 1963 in Victoria, opened up a whole range of playful inventiveness about a potentially serious subject.

Gradually the scarecrow became more momentous and transformed into a crucifixion. Bates recorded his ideas on *(Midnight) Crucifixion* (1961) in his *Journal of Thoughts*, 17 August 1959:

> I am considering a picture of the Crucifixion, 36" x 48"—The Midnight Crucifixion. Midnight because it is the Nadir. Dawn might be the time of the Resurrection. It is winter, the low point of the year. Spring would be the time of the Resurrection. There will be a group of beggars in the foreground—three crosses in the distance, or middle distance. The winter trees will have thorny, spiky branches, there will be snow….[114]

By hinting at the redemptive quality in Christianity —with the open grave and season of Resurrection— Bates suggests affirmation of humanity.

"The strange thing is that some of my latest scarecrows have become angels."[115] The fleur de lis, traditionally the symbol for the Virgin, which Bates used in his architectural practise, made the scarecrow look religious to him. *Fleur de Lis* (1968) features a slightly menacing-faced angel.

Bates's bold and highly colourful cocktail party and reception paintings of the 1960s and 1970s in Victoria, also about bondage and freedom in the human condition, transcend the constraints of symbolic art of the earlier puppet/scarecrow works. In these meaningful transposition of real-life scenes in Victoria, Bates often exposes humankind's inhumanity to humankind of varying degrees in socially charged settings, and by inference, freedom from this. In these socially engaging paintings Bates takes Expressionism to a new level.

The Solitude of the Human Condition

Victoria's Don Harvey has aptly observed "that solitude, that is a very, very prime thing at the heart of Max's work: he is all by himself."[116] For Vancouver's Art Perry: "Bates shows us the isolation and loneliness of being outside of society."[117]

Embodying the "universal quality" or universal truth of solitude, *Circus Man and Blue Monkey* (1953) is an important early post-war Expressionist work. Bates presents despair on the upturned primitive face of this muscular circus man on the fringe of society. His subtle colour, expressive direct marks, sometimes patterned, evoke empathy. In *Drinker* (1955), a linocut, stark white and black angular shapes again underscore despair.

Through images of solitude, Bates ultimately expressed underlying ideas about bondage and freedom in the human condition. This would be another defining characteristic of Bates as an Expressionist. The Calgary works reflecting solitude are more explicit compared to his later enigmatic Victoria works such as the cocktail party paintings.

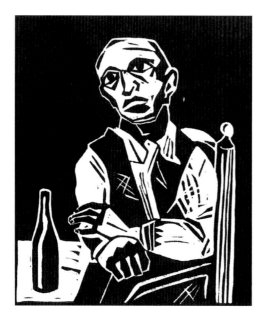

Maxwell Bates, *Drinker* (1955)
linocut,18.1 x 15.2 cm., Private Collection

 Appearance/Reality

In Calgary in 1958 Bates knew his essential aim in his post-war art:

> Experience gives me increased ability to transpose what I see. My intention is to transpose meaningfully. This amounts to expressionism... Good painting must offer something meaningful to the spectator, but it may be enigmatic... the aim is to convey something on one's own terms to the spectator who can respond.[118]

Through the appearance/reality aspect of Expressionism, Bates could paradoxically deliver meaning. Again, the works that play with the relationship between appearance and reality often have a fundamental issue at their core: bondage and freedom within the human condition. *In The Kitchen* (1921) showed Bates's early essential interest in appearance/reality and bondage and freedom within the human condition.

The Victoria years from 1962 to 1980 gave Bates more time to develop this key aspect of his later art. Appearance/reality then had more relevancy to him personally. Paralyzed on the left side of his body after a severe stroke in November 1961 in Calgary, Bates never regained the use of his left arm and needed a brace for his left leg. His highly innovative non-allegorical works of the 1960s and 1970s proved that the right-hemisphere of his brain worked. These highly creative Victoria works often deal with the enigma between the appearance and reality of Bates's times through his brilliant use of conceits of wit, paradox, and irony. Technical innovations—such as monoprints with imprints of plastic doilies in lino ink, watercolour, and resists in October 1961, or discarded cast-off embossed newspaper plates used as support for watercolour or gouache in 1978—also enhanced the appearance/reality aspect of Bates's Expressionist art.

So, too, Bates's lithography with his overprinting of colours, facility in drawing, and imprinting of found objects.[119]

Both *Beautiful B.C.* (1966) and *Assassin* (1969) are exemplary Canadian Expressionist works that use the appearance/reality contradiction—here the juxtaposition of title and content—to full advantage. Yet they are different. In *Beautiful B.C.* (1966) much of the content—the dump, overt sexual glance of the tiger-skin coated lady at the viewer—contradicts the title. Although *Family With Pears*, painted thirty-seven years earlier in 1929, shares the same title/content contradiction, in the 1960s and 1970s Bates exploited "the boundless suggestions, both explicit and paradoxical"[120] that he could achieve in his art. Bates became an expert on suggesting the *plausibility* of appearance in his art when, in fact, he was exposing reality. Conversely, *Assassin* (1969) suggests the *plausibility* of reality—that this boy is an assassin—when other content, the boy holding a pot of flowers, for instance, contradicts the title's assertion.

The extraordinary degree of pictorial play in Bates's art between appearance and reality reflects Bates's tremendous confidence as an artist. It also is a key element in why Bates can affectionately be called a twentieth-century Mannerist painter.

Other notable works displaying the *plausibility* of appearance include: *Girl At Cafe Congo* (1963), with its huge androgenous bipartite face; *Duchess of Aquitaine* (1964), where it wavers between appearance and the ridiculous; *Art Nouveau Reception* (1964) (in the *Secrets of the Grand Hotel* series); *The Cocktail Party #1* (1965); and *Kindergarten* (1965) in which "harlequins and skeletons emphasize the message of unease with jarring effect."[121] The title of *Odalisque* (1970) suggests the *plausibility* of reality but instead,

this woman despite exuberant diamond-shaped patterns and polka dots is an aggressive femme fatale.

In *Modern Olympia* (1969) Bates deliberately confounds meaning by introducing the paradoxical appearance/reality aspect to title and content. Isn't this *Modern Olympia* lovingly receptive to a male spectator's sexual wishes compared to Manet's *Olympia* (1863) (the term "Olympia" in Manet's time was a common name for a prostitute)? But why is a copy of Emile Zola's *Nana*, a novel about a prostitute, placed beside Bates's *Olympia* and why the red background? Underscoring the loving, non-prostitute meaning of this painting, however, Bates includes a cat whose back is not arched nor tail raised as in Manet's *Olympia*.[122] In short, in his *Modern Olympia* (1969) Bates challenges parody-making of slightly more than a century ago—Manet's parody of Titian's *Venus of Urbino* (1538) painted during the High Renaissance—with his witty contemporary parody.

Destiny/Free Will

Man's destiny interested Bates even as a child looking at his parents' Tarot cards in the living room of their Calgary home. In London he studied astrological books and, with an astrologer, compiled charts. A page from his astrology notes outlined the Zodiac with corresponding signs for "organs and parts of body ruled," physiology, and diseases according to "the Sumerian and Akkadian notes on Euphrates."[123] Another page gave signs for "point of love, marriage, catastrophe, fatality, private enemies, understanding and honour." He brought forth this arcane knowledge when he devised horoscopes for friends. As a POW, Bates foretold the assassination attempt on Hitler.

Bates's post-war art is populated with active participants in revealing the destiny of man: fortune tellers and gypsy caravans (begun in 1943). Indifferent gypsies move along with their caravan in *Parade in the Graveyard* (1965) seemingly capable of telling fortunes though ironically short-lived by the painting's title.

But free will also interested Bates. "Max did believe certainly in the influence of the stars but maintained that influence was not absolute but could be modified by the exercise of free will."[124] *Chess Players* (1926), a pencil drawing, and *Chess Game* (1933), an oil—each highly integrated compositions—affirm his belief in free will while *Chess Players* (1974), an ink and wash drawing, confounds this interpretation with its impossible chessboard.

Bates reveled in the fun he could provoke especially in his destiny works. But these works suggesting destiny/free will in life can take on a more serious meaning. In an article Bates outlined the important relationship between free will, destiny, loneliness, creating art, nature, and rhythm (championed in his POW Notebook).[125] Ultimately through the universal truth of destiny and free will Bates could express his underlying statements about bondage and freedom within the human condition.

 Life/Death

A few important works from 1963 on suggest—some more blatantly than others—life and death. In *Two Brothers* (October 1964), life and death appear as a powerful iconic image, whereas in its companion piece, the highly integrated *Duchess of Aquitaine* (1964), life and death predominate as far as the first verse of Bates's poem "God Bless Duchess of Aquitaine"[126] and the pairing of richly coloured patterned companions in his busy textured Spanish garden allow.

But Bates also painted a subtler way, a more personal way, of suggesting life and death, of "Et in Arcadia ego"[127] or "Even in Arcady there am I" (where I is Death), or "Even in Arcadia I, Death, hold sway."[128] After his first stroke in November 1961 Bates painted *Girl at the Cafe Congo* (1963) with its notably bipartite dark blue and white face. In the same year of his second stroke, he painted *Girl With Red Table* (1978) with its bipartite 3/4 light, 1/4 dark face. These and other light/dark faces—some more androgynous than others—could allude to Bates's partial paralysis of his body. But they also could suggest life and death. As a further way of suggesting the human continuum of life and death, in *Standing Woman in Red Interior* (1978), Bates paints simultaneous viewpoints like the Egyptians of profile in light and frontal in dark.[129] These physically unified viewpoints serve well Bates's ultimate profound unity of opposites: bondage of the human body and the promise of freedom, eternal life.■

Maxwell Bates held such a vision for art.

> The artist moves in a forest of intimations. Intimations of what? Of how opposites may be resolved, polarities apprehended without the abyss between their terms; absurdities understood. A work of art is, therefore, an answer we are badly in need of—we should say a masterpiece, not merely a work of art. The answer is on the side of co-operation, integration, togetherness as opposed to isolation and chaos. The answer is moral—it is a religious statement of affirmation.[130]

This essay has traced Bates's unique path and contributions to Canadian art in the twentieth century.

It is the confounding aspect of the meaningful universal truth of appearance and reality that for him, however, distinguishes his art within the Expressionist canon. This aspect also endears us to him. Through it, Bates achieved an important aspect of the visual arts, which he championed in his Prisoner of War Notebook: "Highly developed man must escape beyond space and time. The visual arts effect an escape from both at once."[131] By including time in his art through his deliberate confoundment of appearance and reality, and their resulting reverberations, Maxwell Bates ensures that his art simultaneously and paradoxically is linked to the human condition and can effect this transcendence. Taken as a whole his post-war art within the Expressionist canon can be regarded as a remarkable culmination of his search for meaning and social justice, and of his unitary ideas available to us in his POW Notebook about dilating the present through rhythm to links with eternity.

> And in my soul
> Feelings of some scarcely perceptible
> Great beauty,
> Some words of God,
> Not quite invisible.

Maxwell Bates, from "Intimations", 1953, Calgary.

SOME PROBLEMS OF ENVIRONMENT

(By ——Maxwell Bates)

The three Prairie Provinces have proved themselves even less sympathetic to the original artist than the rest of the country. Talent appears here as elsewhere; but an unsympathetic environment acts as an emetic force on those who do not conform to its philistinism, or do not care to put up with its indifference. They go to other parts of Canada culturally more mature, or to the United States.

The causes lie deeper than the mere insufficiency of economic patronage in a comparatively sparsely populated area for, if the population were to increase WITH THE SAME SENSE OF VALUES THAT HAS PREVAILED, the original artist would still remain apart from the life of his community. He would still attempt to find appreciation and a more mature sense of values elsewhere. Yet if the most adventurous and enquiring minds occupied with the arts can find no acceptance, and sooner or later leave the area, what hope is there for improvement ?

But if may be of interest to glance at the reasons why the Prairie Provinces remain a culturally backward area. Everyone who discusses the question thinks at once of the fact that it was a pioneer region where there was no time for any activities other than the practical effort to make a living. But that there were time and energy left over from that cardinal necessity is shown by the strong religious movements that have always flourished in the area, often of a fanatical and absorbing nature. Of the two compensating activities of the spirit – religion and art – religion has been entirely dominant. Without doubting for a moment the necessity of religion to a people, the fact is that conventional religion, especially those creeds that are fundamentalist and ultra-protestant, has tended to destroy the aesthetic reaction to life with which every man and woman is born, and without the development of which no full and rich life can be achieved. For underlying the extreme Protestant creeds is the belief that life is evil; that all beauty is vanity – a thing of the flesh and therefore, in this distorted view, of the devil. A sterile puritanism is not ground in which the arts can grow. Only materialism can flourish, as has been amply proved by history even if, as must be admitted, it has sometimes a mitigating humanitarian tinge.

If puritanism is the main reason, there is another almost as important; and one for which no one is to blame. Immigrants in Canada, if they forsake the cultural traditions of their country of origin, can find nothing to replace them except the prevailing humanitarian materialism. On the other hand, if they retain their cultural values it is difficult for them to enter fully into Canadian life —- most of their values being irrelevant or even antagonistic to their new environment. Indeed, it is hard for an adult to adapt himself to a new country. For most of them, as for the majority of the Canadianborn population, self-expression and aesthetic appreciation depend on the radio, commercial films, dancing and sport. Small wonder, then, that the original artist finds little appreciation or understanding of his work.

Nevertheless, a great opportunity exists for the artist, whatever his medium, to make an art that embodies and is informed by those qualities which differentiate the Prairie Provinces from any other region in the World. These qualities exist. They are apprehended, however vaguely and dimly, by everyone who has lived there. For the painter, for instance, here is a region that has

Maxwell Bates,
"Some Problems
of Environment",
Highlights 2
(December 1948): 2–3

Part III

There was one who was always above the others and that was Max Bates. To my friends and I he was Mr. Bates (the distinguished Artist).[132]

Ted Godwin

In Alberta we regard Maxwell Bates as dean of our modern painters.[133]

Illingworth Kerr

Max Bates was the one outside of the school that i lookt up to as an artist. He was certainly one of the prime mentors.[134]

Roy Kiyooka

Max was the first adult male outside of Jock [Macdonald] who took art seriously to the proper level.[135]

Ron Spickett

Maxwell Bates was Alberta's first artist to embrace modernism fully and Canada's premier Expressionist of the twentieth century.

Michael Morris has astutely observed: "Max drew in what was relevant to his own being."[136] Alberta was a definite part of that being. Having lived here for forty-one of his seventy-four-year long life, Bates knew Alberta intimately.

In fact, Bates published profound opinions about the effect of the prairie environment on an artist. Like Borduas in "Refus Global" of the same year, Bates identified "conventional religion" in 1948 as one of two problems which made the Prairies "less sympathetic to the original artist than the rest of" Canada.

> conventional religion especially those creeds that are fundamentalist and ultra-Protestant, (which) has tended to destroy the aesthetic reaction to life, with which every man and woman is born, and without the development of which no full and rich life can be achieved. For underlying the extreme Protestant creeds is the belief that life is evil; that all beauty is vanity....A sterile Puritanism is not ground in which the arts can grow.[137]

But, despite these and other conditions, Bates's art and other modernists' art did grow in Alberta. Besides his accomplishments as a figurative artist, Bates's achievements as a landscape artist have already been assessed.[138] Bates needed evidence of man in his landscapes. He wrote insightfully about the visual effect of the prairies: "Beyond the city street lies the prairie under an immense sky. Here man is insignificant."[139] And later, in the same article, Bates described "the insistent duality of earth and sky."

In truth Bates was an insider to the Alberta art scene especially between 1946 and 1961. He was highly regarded amongst fellow artists and the public at the Coste House, Calgary's arts centre (1946–1959). A full-time architect, Bates designed and built Calgary's St. Mary's Cathedral (1954–1957). In his address on "The Architect and Society" for the inaugural 1956 Banff Session for international architects, Bates encouraged other architects to know more about the work of sculptors and mural painters for commissions. In his own practise Bates commissioned Luke Lindoe to create the Madonna and Child for the facade of his St. Mary's Cathedral. In short, an active and important force, Maxwell Bates held great presence in Alberta.

Forty-three years ago in 1962 or two generations ago, after a major stroke, Bates left Alberta. Absence has replaced presence. Bates has become marginalized, an outsider in Alberta's cultural consciousness. Competing collections in Alberta's public art galleries and museums, competing interests and agendas, competing memories, standard inclusive national movements such as "art for a nation" compared to "regionalist artist" from Alberta or B.C. and "official war artists" and different movements internationally such as postmodernism, gender, ethnicity, post-structuralism have prevailed and have all reshaped Alberta's cultural consciousness. A cultural amnesia has almost occurred!

Yet Maxwell Bates did live and create art here, and when he lived there, his point of reference was Alberta (until 1962 and sometimes after).

This essay, the Virtual Museum of Canada site *Maxwell Bates: Artist, Architect, Writer* <**www.maxwellbates.net**> hosted by the Art Gallery of Greater Victoria, and the exhibition and catalogue[140] for *Maxwell Bates: At The Crossroads of Expressionism* organized by the The Edmonton Art Gallery will all help a re-evaluation of the contributions of this great Canadian Expressionist to occur.

Nancy Townshend

Endnotes

1 Fredrik S. Eaton in a letter to author, 21 April, 2003.

2 Velasquez's *Dwarf Don Diego de Acedo, El Primo* c. 1636–38, and Ribera's dwarfs, Murillo's and Manet's beggars.

3 Don Harvey in conversation with author, 2 January, 2004.

4 Manet's *A Philosopher (Beggar With Oysters)* c. 1864–67, *Philosopher (Beggar in a Cloak)* c. 1864–67 (oils on canvas, Art Institute of Chicago), and Manet's *The Absinthe Drinker (A Philosopher)* 1858–59.

5 Don Harvey in conversation with author, January 2, 2004.

6 P. K. Page, "Maxwell Bates," *artscanada* (April 1970) 62.

7 Close in meaning to the Mannerist term "concetto" or "conceit" defined by Arnold Hausser as: "The concetto, that quintessence of everything that is understood by point, wit, obscure and bizarre allusion, and above all paradoxical association of opposites," Arnold Hauser, *Mannerism: The Crisis of the Renaissance and the Origin of Modern Art* (London: Routledge & Kegan Paul, 1965) 297.

8 Don Harvey in an interview with Michael Morris and Nancy Townshend, April 2003.

9 Maxwell Bates, *A Wilderness of Days*, (Victoria: Sono Nis Press, 1978) 133.

10 Prior to this Calgary has been regarded as negative: see Ian Thom, *Maxwell Bates: A Retrospective*, (Victoria: Art Gallery of Greater Victoria, 1982) and more recently Jonathan Browns, *Melancholy* (Ottawa: The Ottawa Art Gallery, 2002).

11 Maxwell Bates in an interview with Terry Guernsey, 1972, Vancouver Art Gallery Archives, p. 9, transcript.

12 Holme, C. (ed.), The *Studio* Special Autumn Number 1904: *Daumier and Gavarni* with Critical and Biographical Notes by Henri Frantz and Octave Uzanne, (London: *The Studio*, 1904).

13 Maxwell Bates, *Journal*, 10 November, 1959. See also Maxwell Bates in an interview with Frank Nowosad, 5 April, 1977, and Robin Skelton, "Maxwell Bates: Experience and Reality," *The Malahat Review*, 20, (October 1971) 58.

14 Bates painted at least one Don Quixote which was nominated as the "best book of all time" in 2002. De Cervantes wrote and published it in 1605 and 1615.

15 Maxwell Bates, "Biographical Notes," Maxwell Bates *fonds*, 439/89.1, Box/file 15.12, Special Collections, University of Calgary Library.

16 P. K. Page, "Max and My Mother: A Memoir," *Border Crossings*, 7 (October 1988), 74–75.

17 Maxwell Bates, "Biographical Notes," Maxwell Bates *fonds*, 439/89.1, Box/file 15.12, Special Collections, University of Calgary Library.

18 Maxwell Bates, Foreword, Vermicelli, Maxwell Bates *fonds*, 439/89.1, Box/file 8.26, Special Collections, University of Calgary Library.

19 Maxwell Bates, "Biographical Notes."

20 Maxwell Bates, as quoted in P. K. Page, "The Self-Contained Castle," *Border Crossings*, 7 (October 1988) 78.

21 ibid.

22 Maxwell Bates, in Life Works, a film on Maxwell Bates by Janice Starko.

23 Maxwell Bates, "The Painter W. L. S. (Stevenson): a Memoir," 1, Maxwell Bates *fonds*, 439/89.1, Box/file 10.2, Special Collections, University of Calgary Library.

24 ibid.

25 "Goya...were among those artists that helped me most," Bates, "Biographical Notes." Bates appreciated the expressive aspects in Goya's art and indirectly "the intensely spiritual or mystical component of some Spanish art" that some nineteenth century French artists had found and emulated. See *Velasquez to Manet* exhibition at the Metropolitan Museum, 2003.

26 Bates kept a copy of Velasquez's *Maids of Honor* at his death as well as El Greco's *Nino de Guevara*.

27 Maxwell Bates, "The Painter W.L.S. (Stevenson): a Memoir", Maxwell Bates *fonds*, Special Collections, University of Calgary Library.

28 ibid., 7.

29 A Post-Impressionist movement that reacted against the formlessness of Impressionism and the Impressionists' reliance on external objects as subject matter. Its chief characteristics were: flat areas of relatively unmodulated colour, ususally delineated by contours; emphasis on pattern; and artist's subjectivity. Synthetists sought to synthesize subject and idea with form and colour.

30 Bates, "Biographical Notes." Bates described *Male and Female Forms* 1928 as "a small non-objective painting in Calgary in 1928." Maxwell Bates in a letter to Russell Harper dated December 14, 1963, McCord Museum.

31 ibid.

32 in the Opportunity Gallery 13 December 1929–14 January 1930, juried by Neumann. In 1927, Stevenson was juried in the first year by Georgia O'Keefe, Rockwell Kent, Robert Henri, John Sloan, and others. Art Gallery of Greater Victoria archives.

33 Bates, "Biographical Notes."

34 Bates," Notes," Maxwell Bates *fonds*, Special Collections, University of Calgary Library.

35 Didactic panel, Art Institute of Chicago, 2001.

36 Bates, in an interview with Terry Guernsey, *Maxwell Bates Retrospective*, (Vancouver: Vancouver Art Gallery, 1971).

37 The incorporation into European art of certain intrinsic, visual characteristics of Japanese art such as asymmetrical compositions, pattern, diagonal thrusts of compositions and cropping.

38 Thanks to Kyla Legard.

39 Wife of Consul for Netherlands in Manchester.

40 *Exhibition of 100 Watercolour Drawings*, 17 August–29 September, 1935 at the Royal Museums Art Galleries in Peel Park. Bates exhibited *The Fair Ground*, *Café* and *Two Men*.

41 H. G. Wells, Lord Berners, Lord Sandwich, Margot Asquith, the Contemporary Art Society, Sir Michael Sadler, Mr. E. Lockett, Maurice Browne and Mrs. Jamieson. Kathleen Walne, 18 July 2002, and Mrs. Wertheim in a letter dated 14 April, 1933 to Mr. Williamson, Archives, Salford Museum and Art Gallery.

42 See The Ford Collection I and II, 60th volume of the Walpole Society, 1998.

43 He also commissioned a five-sided waste paper basket with Japanese subjects. Bates painted two watercolour sketches of Ford, David, and Marcus Cheke (a diplomat, later British ambassador to the Vatican).

44 Ford remembered Bates's *Last Supper* 1932, a large watercolour.

45 Maxwell Bates in an interview with Terry Guernsey, Vancouver Art Gallery Retrospective, 1973, unedited transcript, 4.

46 Bates decried the Surrealists "as the enemies of painting as a living art" in Maxwell Bates, "Surrealism," *The Listener*, 5 August 1936 (16- 395) 274. Herbert Read, in his "Introduction" to *International Surrealist Exhibition* at the New Burlington Galleries in 1936, stated that "the romantic artists of every age… appeal…to the sensibilities of succeed-ing ages….Superrealism…is the roman-tic principle in art." Read then categorized Surrealism as "the desperate act of men too profoundly convinced of the rottenness of our civi-lization." In Maxwell Bates, "Canadian Art," *The Listener*, c. 3 November 1938, Bates replied to Herbert Read's negative review of *100 Years of Canadian Art* at the Tate in Herbert Read, "At the Tate Gallery," *The Listener*, 27 October 1938.

From 1933 to 1939 Read was editor of the *Burlington Magazine*, which Bates read, and a close friend of Henry Moore and Twenties Group members Barbara Hepworth and Ben Nicholson.

47 Herbert Read, *Art Now*, (London: Faber & Faber, 1933) 76. Read discussed Expressionism briefly in *The Meaning of Art* (London: Faber & Faber, 1931). Read's precursor, Paul Fechter, in his book *Der Expressionismus* (Expressionism) (Munchen: R. Piper & Co., 1914), considered the art of Der Brucke, Der Blaue Reiter, and Kokoschka as Expressionist and defined it as emotional and spiritual—the "metaphysical necessity of the German people." Shulamith Behr, *Expressionism*, (London: Tate Gallery, 1999) 8.

48 Herbert Read, *Art Now*, 86.

49 Herbert Read, *Art Now*, 82; true of Die Brucke's art for Read.

50 Herbert Read, *Art Now*, 84–85.

51 Roger Fry, review of Herbert Read's *Art Now*, *New Burlington* magazine LXIV, May 1934, 242. Read discussed Fry's views on rhythm, for instance, in *Art Now*, 78. Bates read Fry's *Vision and Design* (1920) in Calgary.

52 Roger Fry, Review of Herbert Read's *Art Now*, *New Burlington* magazine, LXIV, May 1934, 245.

53 Maxwell Bates, "Naive Painting," *Phoebus Calling* (Spring, 1934) 20. A Wertheim publication.

54 Review of Naive Painting show, Wertheim Gallery, *The Times*, 18 April 1934, Wertheim Archives.

55 *The Times*, 17 November 1935, Wertheim Archives.

56 Thanks to Kyla Legard.

57 "Unit One": A New Group of Artists', Letter to *The Times*, 12 June 1933. Unit One exhibition opened in April 1934 in London and Herbert Read edited *Unit 1: The Modern Movement in English Architecture, Painting and Sculpture* in 1934. Paul Nash published articles on Unit One in *The Listener*,

5 July 1933, and in Letter to *The Observer*, 22 April 1934.

58 Robin Skelton, "Maxwell Bates: Experience and Reality," 81.

59 Professor Andrew Causey, *Life and Style: the Art of Edward Burra*, Hayward Gallery, London, 1 Aug.–29 Sept., 1985, Arts Council of Great Britain.

60 Barbara Ker-Seymer, letter 4 July 1982, quoted in M. Kay Flavell, *George Grosz: A Biography*, (New Haven and London, 1988), and reproduced in Edward BURRA, Tate Britain, 21.

61 exhibited in the Leicester Galleries in London, May–June 1932 (#54 as *Snack*).

62 Maxwell Bates, "The Self-Contained Castle: Maxwell Bates and P. K. Page," in Conversation, *Border Crossings*, 7 (October 1988) 78.

63 Robin Skelton, "Maxwell Bates," 64.

64 Jorn Merkert, as quoted in Christoph Zuschlag, "An 'Educational Exhibition'", *Degenerate Art: The Fate of the Avant-Garde in Nazi Germany*, Los Angeles County Museum of Art (New York: Henry N. Abrams, Inc., 1991) 89.

65 Bates could read about the Degenerate Art show in Munich in the British press: Robert Medley's "Hitler's Art in Munich", *Axis*, 8 (winter) 1937, and Causton Bernard, "Art in Germany under the Nazis," *The London Studio*, (12–68, November 1936) 235–46.

66 Herbert Read, "Introduction," catalogue, *20th Century German Art*, 6–7, New Burlington Art Gallery, July 1938, National Art Library, Victoria and Albert Museum.

67 Such as the London *Times Weekly*, 14 July, 1938, and *Times Literary Supplement*, 23 July, 1938,—"Modern German Art—till now," *Studio* (September 1938) 160.

68 Carla Schulz-Hoffmann, *Max Beckmann: Retrospective* (St. Louis: St. Louis Art Museum, 1984) 266.

69 See *Beggar-King* 1963.

70 ibid.

71 in London *Times Weekly* (14 July 1938).

72 Max Beckmann, "On My Theory of Painting", *20th Century German Art*, New Burlington Art Gallery, London, July 1938.

73 Some of Bates's art in the Wertheim Collection was destroyed by a bomb; Mrs. Wertheim gave the remainder to the Salford Museum and Art Gallery and Towner Art Gallery (1972 bequest) in Britain and the Auckland Art Gallery in New Zealand (2 December 1948).

74 Winston Churchill referred to this in his speech "*This* was Their Finest Hour", 18 June 1940, House of Commons, London.

75 Maxwell Bates, *A Wilderness of Days: An artist's experiences as a prisoner of war in Germany*, (Victoria: Sono Nis Press, 1978), 87. This is the only reference to the Notebook in his 133-page documentary account.

76 Maxwell Bates's *Prisoner of War Notebook* is kept in the Maxwell Bates *fonds*, acc. no. 439/89.1, Box/file 15.1, Special Collections, University of Calgary Library.

77 Karrie Davis, ACAD student, February 2000.

78 Part I records excerpts from Bente Croce's *Aesthetics as Science of Expression and General Linguistic* (1909, English translation), Herbert Spencer's *First Principles*, and Ouspensky's *A New Model of the Universe*.

79 Maxwell Bates, *Prisoner of War Notebook*, Part II, 12 handwritten, 21 transcribed.

80 ibid., Part II, 14 handwritten, 24–25 transcribed. Italics are author's own.

81 ibid., Part II, 15 handwritten, 27–28 transcribed.

82 Compare notebooks and documents of Arct Squadron Leader B (88/58/1), Campbell Squadron Leader CNS (86/35/1), R.H. Lee (98/26/1), R. Watchorn (95/39/1).

83 Maxwell Bates, *Wilderness of Days: An artist's experiences as a prisoner of war in Germany*, (Victoria: Sono Nis Press, 1978) 55.

84 Maxwell Bates, *Prisoner of War Notebook*, Part II, 35 handwritten.

85 Bates only met two dozen Canadians for a couple of weeks during 1943 and 1944 at the camp. Otherwise the POW camp held 100 British POWs, Polish POWs and slave labourers, Ukrainian slave labourers, and Russian soldiers.

86 Petra Von Morstein, Professor Emeritus of Philosophy, University of Calgary in an e-mail dated 8 February 2001 to the author.

87 Maxwell Bates, *A Wilderness of Days* 87. This is the only reference to the Notebook in his 133-page documentary account.

88 Maxwell Bates, Vancouver Art Gallery interview, 8.

89 Maxwell Bates in a letter dated 15 February 1945 to his parents.

90 Maxwell Bates in a letter dated 15 May 1942 to his brothers Newton and Billy.

91 Robin Skelton, "Maxwell Bates: Experience and Reality," 85.

92 George White, a fellow POW, in an interview with Kay Snow, 10 October 1988, Kay Snow *fonds*, 549/94.4, Special Collections, University of Calgary Library.

93 Bates also received books through the Prisoners and Captives Association and the European Relief Fund. "Conrad, Kipling, Marcel Proust and Chekov and Dostoevsky are authors I like. Also Bernard Shaw." Maxwell Bates in a letter dated 14 March 1941 to his parents.

94 Maxwell Bates, *Wilderness of Days*, 117.

95 *Civilian Prisoners*, Germany or *Political Prisoners* 1945, w.c., 9" x 12". Photo in Maxwell Bates *fonds*, Box 15.3, Special Collections, University of Calgary Library. *Men From Concentration Camp (Germany), (Event of April 23, 1945)* July 1963, watercolour, 18" x 20 3/4;"

and two illustrations in *Wilderness of Days*, 116 and 118, are later works of this image.

96 Cyril Connolly, *Unquiet Grave: A Word Cycle by Palinurus*, (London: Horizon, 1944). Thanks to Michael Morris.

97 Maxwell Bates, *Prison Notebook*, Part Two, 14 handwritten, 24–25 transcribed, Maxwell Bates *fonds*, 15.1, Special Collections, University of Calgary Library.

98 Maxwell Bates, *Prison Notebook*, Part Two, 32 handwritten, Maxwell Bates *fonds*, 15.1, Special Collections, University of Calgary Library.

99 Maxwell Bates, "Plan For Work," c. 1949, Maxwell Bates *fonds*, Special Collections, Box/file 14.2, University of Calgary Library. Author's emphasis.

100 Maxwell Bates, "Some Problems of Environment," *Highlights* 2–8, (December 1948) 2–3.

101 Roy Kiyooka, "Intersections," *Roy Kiyooka: 25 Years* (Vancouver: Vancouver Art Gallery, 1975) 4.

102 Some of Bates's Prairie People works appeared in the *Calgary Group*, a nationally travelling show from 1947 to 1949, in Vancouver (Vancouver Art Gallery and UBC) November 1947, Victoria, Calgary (Coste House), Saskatoon (Saskatchewan Art Centre), London and Windsor (Willistead Gallery) March 1949.

103 Barker Fairley, "What is Wrong with Canadian Art?" *Canadian Art* (VI, 1, Autumn, 1948) 25. Fairley had asked: "What is it that prevents the Canadian artist from…treating the human subject with the imagination that he enjoys in doing skies and forests?" In contrast Bates encouraged fellow ASA artists to create figurative art in his article "Graphic Art in Alberta," *Highlights 2* (March 1948) 3.

104 Head of the Art Department of Provincial Institute of Technology and Arts 1946–1947. Bates's and Macdonald's correspondence is kept in the McCord Museum Archives.

[105] Jock Macdonald in a letter dated 2 July 1954 to Bates, J. W. G. Macdonald – Letters to Maxwell Bates, McCord Museum.

[106] Bill Stavdal, "'They Must Come to Me,'" *Daily Colonist*, 17 February 1970, 20.

[107] George Gooderham, 30–31, Glenbow Archives.

[108] His earlier Expressionist watercolours *Beer Drinkers*, *Ukrainian Women* and *Miners* appeared in his one-man show at Canadian Art Galleries in Calgary 25 January–1 February 1947 and at the Vancouver Art Gallery 29 April–11 May 1947.

[109] His favourite *Puppet With Red Background* (1959/1960) or *Red Puppets* is lost. Of 894 artworks recorded in Bates's Sales Book, only nine including the show's *West Indian Puppets* (1972) have "puppets" in their titles.

[110] Robert Ayre, "Calgary Painters Exhibit," *Montreal Star*, 23 February 1957, as quoted in Kay Snow, *Maxwell Bates: Biography of an Artist*, 102.

[111] Of 894 artworks recorded in Bates's Sales Book, only nineteen have "scarecrows" in their titles.

[112] Maxwell Bates in a letter dated 4 October 1966 to Kenneth Saltmarche, reprinted in Kay Snow, *Maxwell Bates: Biography of an Artist*, 164.

[113] Maxwell Bates in an interview with Terry Guernsey, *Maxwell Bates Retrospective*, Vancouver Art Gallery, 1973, 14.

[114] Maxwell Bates, "Journal beginning in 1957," 33. *Midnight Crucifixion* (1961) is in the collection of the Art Gallery of Windsor.

[115] Bates in article by Bill Stavdal filed to *Time* magazine, 1968.

[116] Don Harvey in an interview with Michael Morris and Nancy Townshend, April 2003.

[117] Art Perry, "Maxwell Bates: Kyle's Gallery, "*Vanguard* (May 1979) 25.

[118] "Maxwell Bates On Painting," *Canadian Artists Series I*: *Bates/Humphrey*, National Gallery of Canada, Ottawa, 1958; reprinted in *Maxwell Bates Retrospective Exhibition*, Norman Mackenzie Art Gallery, 30 November 1960–2 January 1961.

[119] Bates and John Snow delighted in creating lithographs from the same found objects! Pete Savage to Nancy Townshend, December 2003.

[120] Frank Nowosad, "I don't pretend to be anywhere near the avant-garde: Notes on Maxwell Bates," *Monday Magazine* (24–30 October 1977).

[121] Patricia E. Bovey, *A Passion For Art*: *The Art and Dynamics of the Limners* (Victoria: Sono Nis Press, 1996) 59.

[122] With its reference to erotic associations similar to cat imagery in Baudelaire's poetry.

[123] Maxwell Bates, Foreword, Vermicelli, Maxwell Bates *fonds*, 439/89.1, Box/file 11.9, Special Collections, University of Calgary Library.

[124] ibid.

[125] In it Bates asserts that knowing that we, as humans, are responsible for our own destiny is a burden that drives us to desire oneness with nature again. Since we cannot, Bates says, we create artificial links with nature instead, through art, and in art, rhythm "a tendency to unity which annihilates time and space and removes the differences that make one think stand apart from another." Man creates art to become "part of the great cosmic whole" again.

Maxwell Bates, –, c. 1958, Maxwell Bates *fonds*, Special Collections, Box/file 15.4, University of Calgary Library.

[126] "God bless the Queen of Aquitaine/ With fifteen dead-men in her train./ She cursed the slain;/Their corses piled in caves in Spain." September 1964, poem, in Kathleen M. Snow *fonds*, acc. no. 549/94.4, box/file 2.8, Special Collections, University of Calgary Library.

[127] Guercino *Et in Arcadia ego* 1621–23, and Poussin *Et in Arcadia* 1630, Chatsworth, Devonshire Collection and *Et in Arcadia ego* 1635, Louvre, Paris.

[128] Erwin Panofsky, *Meaning in the Visual Arts*, (Middlesex: Penquin Books, 1955) 350–367. I would like to thank Don Harvey for his insights on this aspect of Bates's art.

[129] Thanks to Don Harvey for pointing this out to me in the painting *Standing Woman in Red Interior* (1978).

[130] Bates, "Journal of Thoughts", 1959.

[131] Maxwell Bates, *Prisoner of War Notebook*, Part II, 12 (handwritten), Maxwell Bates *fonds*, acc. no. 439/89.1, Box/file 15.1, Special Collections, University of Calgary Library.

[132] Ted Godwin, "Travelling With Max", 2, Ted Godwin, (unpublished memoirs).

[133] Illingworth Kerr in an undated letter to Miss Guernsey, Maxwell Bates Retrospective, Vancouver Art Gallery.

[134] Roy Kiyooka in an interview with Chris Varley, *Roy K. Kiyooka*: *25 Years* (Vancouver: Vancouver Art Gallery, 1975) 4.

[135] Ron Spickett in an interview with Nancy Townshend, Dec. 1996, 1.

[136] Michael Morris in an interview with author, September 1, 2001.

[137] Maxwell Bates, "Some Problems of the Environment", *Highlights* vol. 2, #8, (December 1948), pp. 2–3. Also an abridged version titled "The Prairie Artist" appeared in an Alberta newspaper, December 1948.

[138] Nancy Townshend, *Maxwell Bates*: *Landscapes/Paysages* 1948–1978, Medicine Hat Museum and Art Gallery, 1982.

[139] Maxwell Bates, "Some Reflections on art in Alberta," *Canadian Art* 13 (Autumn 1955): 183–87.

[140] An abridged version of this essay appears in this catalogue with permission from the Edmonton Art Gallery and Nancy Townshend.

Acknowledgements

I would like to thank Bill and Gisela Bates for their continual support; Mr. Elwood Kintzle of the Maxwell Bates estate; Apollonia Steele and Marlys Chevrefils of Special Collections, University of Calgary Library housing the Maxwell Bates *fonds* and Kathleen M. Snow *fonds* on Maxwell Bates, and Dave Brown of Image Centre Services of the University of Calgary.

Research on Maxwell Bates involves a world-wide search. For Bates's British period (1931–1939), I thank: Philippe and Lucilla Garner of the Lucy Carrington Wertheim family and the late Jimmy Hume who recorded every Bates painting exhibited with the Wertheim Galleries; the late Sir Brinsley Ford and his family; Mrs. Kathleen Walne/Ward of the Twenties Group; Richard Ingleby; the National Arts Library of the Victoria and Albert Museum; Melanie Blake of Photographic Survey of the Courtauld Institute of Art; Christopher Bastock of the Tate Archives and Library; Judith Sandling of the Salford Museum and Art Gallery Archives, and Laura Jocic and Mary Kisler at the Auckland Art Gallery Toi o Tamaki.

For Bates's POW period (1940–1945), I thank: Bill and Gisela Bates for showing me Maxwell Bates's POW letters to the family; Stephen Walton, Archivist at the Imperial War Museum, London; Dr. Petra Von Morstein, Professor Emeritus of Philosophy, University of Calgary; Karrie Davis, and Diane Morriss of Sono Nis Press.

For Bates's Calgary periods (1906–1931 and 1946–1962), I offer my gratitude to: Cindy Campbell of the National Gallery of Canada Archives, Cheryl Siegel of the Vancouver Art Gallery Library, the McCord Museum Archives, the late John and Kay Snow, P. K. Page, the late Roy Kiyooka, Ted Godwin, Ron Spickett, and Calgary filmmaker Janice Starko.

For Bates's Victoria period (1962–1980), I thank: Don Harvey, Karl Spreitz, Michael Morris, the late Robin Skelton and late Frank Nowosad, Pierre Arpin of the Art Gallery of Greater Victoria and Martin Segger and Caroline Riedel of the Maltwood Art Museum and Gallery, University of Victoria.

The Edmonton Art Gallery offered great support: Director Tony Luppino and co-curator Michael Morris gave valuable insights into an earlier draft of this essay. My appreciation to Catherine Crowston and Pamela Clark. At the Nickle Arts Museum, my thanks to Dr. Ann Davis.

I thank the Hedlin Alberta Cultural Fund of the Works International Visual Arts Society for financial support. To Nelson Vigneault and Inese Birstins at CleanPix, I thank you for outstanding collaboration.

I thank my family immensely, Professor Donald B. Smith of the University of Calgary, sons David and Peter, and Max.

Nancy Townshend
Calgary, December 2004

And in my soul
Feelings of some scarcely perceptible
Great beauty,
Some words of God,
Not quite invisible.

Maxwell Bates, from "Intimations", 1953, Calgary.